IMAGES
of America

SIXTH STREET

IMAGES
of America

SIXTH STREET

Allen Childs, M.D.

ARCADIA
PUBLISHING

Published by Arcadia Publishing
Charleston, South Carolina

Printed in the United States of America

Library of Congress Control Number: 2010929645

For all general information, please contact Arcadia Publishing:
Telephone 843-853-2070
Fax 843-853-0044
E-mail sales@arcadiapublishing.com
For customer service and orders:
Toll-Free 1-888-313-2665

Visit us on the Internet at www.arcadiapublishing.com

*To my parents, Morris and Berta Childs, and
my mentor, Hyman Samuelson*

CONTENTS

Acknowledgments 6

Introduction 7

1. Earliest Images 9

2. The Dreams of Many Cultures Intertwined 35

3. Icons of the Street of Dreams 79

4. The Renaissance of East Sixth Street 111

5. An Hour on Sixth Street Today 117

ACKNOWLEDGMENTS

The Austin History Center was a central point for the research behind this book. I particularly appreciate Peggy Holmes and Daniel Alonzo from the Center. High school classmate Joe Mitchell shared valuable information about Sixth Street's Hispanic life. The George Washington Carver museum taught me about the African American entrepreneurs of East Sixth, and curator Bernadette Phifer was particularly helpful. The colorful history of Austin's Lebanese was well told by Joe Joseph Jr. and Monsignor Don Sawyer. Josh Allen, executive director of the Sixth Street Austin Association, provided rich detail of the reborn Historic Entertainment District. My son-in-law, Ozgur Cakar, took compelling photographs of an hour on Sixth Street today, and old friend Jim Kruger did the same with historical structures. Dub King's Al Bohne, a former air force intelligence imaging specialist, was able to turn the vaguest images into works of art. He warned me of what he called the urgency sensor: when you're in a hurry, the computer senses this and slows down. My brother, Hymen Childs, has been a source of memories of the rough edges and funny stories of the Sixth Street of our childhood. I shall be forever indebted to my assistant, Sylvia Barrios, who worked into the night many times to make this book a reality.

INTRODUCTION

East Sixth Street, now a hub of the live music capital of the world, had its humble beginning as a dirt road, the only level path from the east. Even today, if one drives east on Sixth Street, past Cisco's at Chicon all the way to Govalle, you can clearly see 2 miles to One America Center at Sixth Street and Congress Avenue. Sixth Street is a registered landmark with the National Register of Historic Places.

For over half a century, Sixth was known as Pecan Street since the first maps of the capital city of the new Republic of Texas were drawn up in 1839. Streets were named before there were streets, at least not ones you could turn your wagon around on without ending up in the ditch. The exception was Pecan Street, the natural conduit into the city, where east and west could meet. And everything met on Pecan: the generations, the nationalities, the races, the poor, the rich, the educated, and the ignorant.

Sixth Street, as Pecan became in 1884, has always been the vibrant melting pot of Austin—self-contained and unself-conscious, a place of many firsts and, like Austin, not a few paradoxes.

The dusty road stretching 27 miles to Bastrop east along the Colorado River did not flood when the raging Colorado River decided to jump its banks. These devastating deluges wrecked any building south of Sixth Street, all the way to the river until the 1930s when the Mansfield Dam tamed the beast. And this created the Highland Lakes.

So, buildings could be safely built along this level street, which was level in many other ways besides its topography. Sixth Street was, from its earliest beginnings, a level playing field for merchants and minorities, moneyed dynasties, and little mom-and-pop places. When Austin was a typical segregated society, Sixth Street was not. Its multiracial nature was woven into the fabric of the street, into its buildings, and into the families on whom it left its indelible imprint—like mine. My mom, dad, brother, and I all worked in our endlessly burdensome, always instructive, and sometimes hilarious shoe store at 301 East Sixth Street. I showed up, eight years old, all hands and feet, on Sixth Street in 1950, after the street had been historic but before anybody knew it was.

There is a plaque on the oldest surviving building, the Kriesle Building at 400 East Sixth Street (built around 1860), that tells the story of the street. Named for Mathias Kriesle, furniture maker, undertaker, and patriarch of one of Austin's great medical families, the building's historical citation reads: "This building housed various ethnic business owners: Blacks, Chinese, German, Jewish and Lebanese."

This book is an effort to remember them—through my viewpoint as an eight-year-old child fresh out of Michigan—from former slaves and old Confederate soldiers to those of the descendants of merchant families whose doors first swung open to Sixth Street 170 years ago.

One

EARLIEST IMAGES

The irony of placing this historical plaque in the 100 block of Sixth is that everything that was there is gone. Fortunately, there were few historically significant buildings on that block, only historically significant people. Those included John Bremond and Henry Hirshfeld, merchants turned bankers. (Courtesy of Ozgur Cakar.)

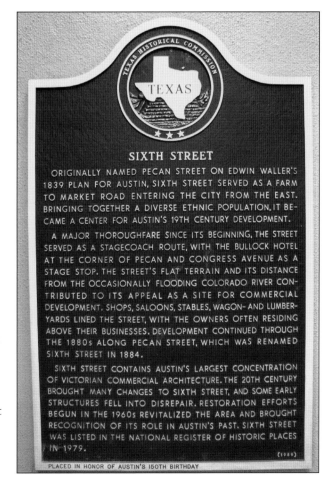

TEXAS HISTORICAL COMMISSION

TEXAS

SIXTH STREET

ORIGINALLY NAMED PECAN STREET ON EDWIN WALLER'S 1839 PLAN FOR AUSTIN, SIXTH STREET SERVED AS A FARM TO MARKET ROAD ENTERING THE CITY FROM THE EAST. BRINGING TOGETHER A DIVERSE ETHNIC POPULATION, IT BECAME A CENTER FOR AUSTIN'S 19TH CENTURY DEVELOPMENT.

A MAJOR THOROUGHFARE SINCE ITS BEGINNING, THE STREET SERVED AS A STAGECOACH ROUTE, WITH THE BULLOCK HOTEL AT THE CORNER OF PECAN AND CONGRESS AVENUE AS A STAGE STOP. THE STREET'S FLAT TERRAIN AND ITS DISTANCE FROM THE OCCASIONALLY FLOODING COLORADO RIVER CONTRIBUTED TO ITS APPEAL AS A SITE FOR COMMERCIAL DEVELOPMENT. SHOPS, SALOONS, STABLES, WAGON- AND LUMBER-YARDS LINED THE STREET, WITH THE OWNERS OFTEN RESIDING ABOVE THEIR BUSINESSES. DEVELOPMENT CONTINUED THROUGH THE 1880s ALONG PECAN STREET, WHICH WAS RENAMED SIXTH STREET IN 1884.

SIXTH STREET CONTAINS AUSTIN'S LARGEST CONCENTRATION OF VICTORIAN COMMERCIAL ARCHITECTURE. THE 20TH CENTURY BROUGHT MANY CHANGES TO SIXTH STREET, AND SOME EARLY STRUCTURES FELL INTO DISREPAIR. RESTORATION EFFORTS BEGUN IN THE 1960s REVITALIZED THE AREA AND BROUGHT RECOGNITION OF ITS ROLE IN AUSTIN'S PAST. SIXTH STREET WAS LISTED IN THE NATIONAL REGISTER OF HISTORIC PLACES IN 1979.

(1989)

PLACED IN HONOR OF AUSTIN'S 150TH BIRTHDAY

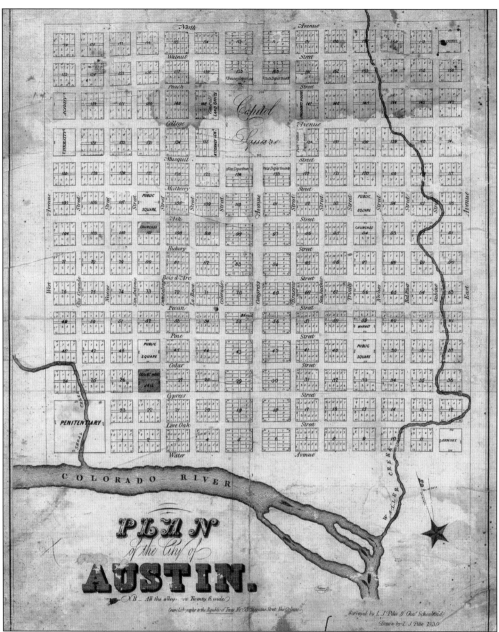

This is the original plan for the capital of the Republic of Texas. French surveyor Louie Jean Pilie's 1839 city plan had a place for everybody. Where the Austin History Center sits today (Guadalupe and Ninth Streets) was to be a church for slaves, and as 14 percent of the city's population was Mexican, he set aside a block for their churches as well. The community wagon yard, half a block off Pecan at Trinity Street, was a thriving marketplace well into the 20th century. The two-block lower left corner, bisected by Shoal Creek, was to be the Republic of Texas's federal prison. It was never built. When the Republic auctioned off city lots, the highest price was paid for the northeast corner of Congress Avenue and Fourth Street at $2,800. Now, from this corner where trains first stopped, the spectacular Frost Bank Tower dominates the Austin skyline. (Courtesy of Austin History Center.)

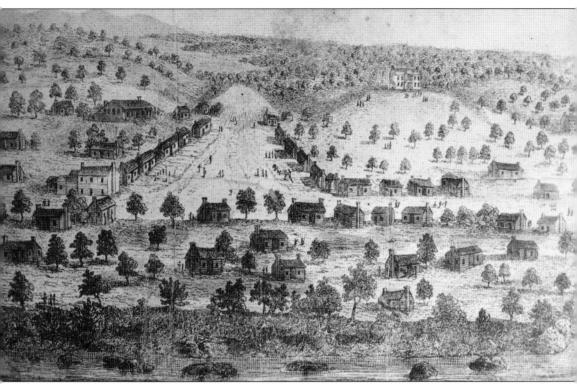

Two years after the committee to select the capital paid $21,000 for this 14-block square, the Republic of Texas had found a home. This bird's-eye view of 1840 Austin shows only Pecan Street and Congress Avenue ascending to its future capital. Affairs of state were carried on in the temporary statehouse, the larger building west of Congress. Pres. Mirabeau B. Lamar's mansion is on the rising hill to the upper right. Pecan is graced with Bullock Hotel, the white two-storied structure at the corner where the stagecoach stopped. (Courtesy of Austin History Center.)

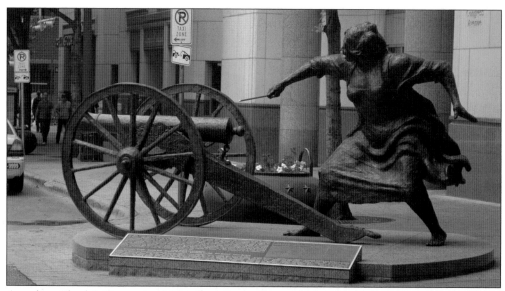

Angelina Eberly's Tavern and Hotel on Pecan Street had welcomed such notables as Texas Republic's second president, Maribu B. Lamar, who stayed with her during his 1839 inaugural visit to the new capital. Having watched her home and tavern burned by Texas's militia in San Felipe de Austin (1834) to keep it from falling into Mexican hands, Angelina was outraged upon discovering Texas Rangers secretly removing the nation's archives from the Land Office across Pecan Street from her hotel. Pres. Sam Houston wanted the capital moved back to the coast, leaving 1842 Austin to die on the vine of this remote hill country. Eberly seized the town cannon, firing it point-blank at the Land Office. Thus aroused, the citizenry organized a posse, who ran the Rangers down north of Austin at Brushy Creek. Surrounded and greatly outnumbered, they surrendered the archives, which were kept thereafter in Angelina's Tavern until statehood in 1845. This larger-than-life statue at Sixth Street and Congress Avenue remembers Angelina Eberly's cannon blast that saved the capital. (Both, courtesy of Jim Kruger.)

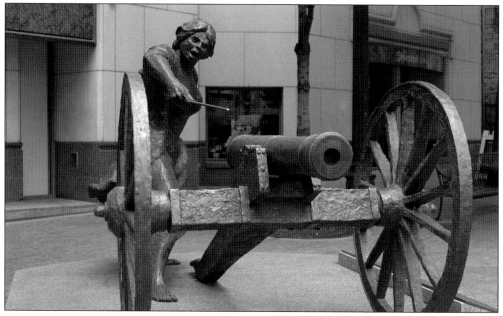

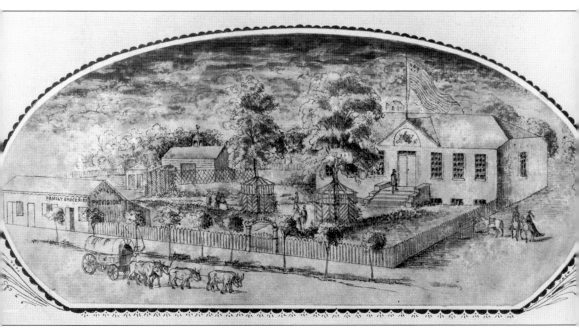

This corner of Trinity and Sixth Streets, and most of the 400 block, was graced by the Buaas Gardens in 1860, featuring Austin's first live music venue from their eight-octave piano. In fact, live music was the only music then. Note the tree-lined street and inviting gazebos surrounding the shading oaks. The 21st century vision of the Historic Entertainment District will look again like the Buaas Gardens of 1860. (Courtesy of Austin History Center.)

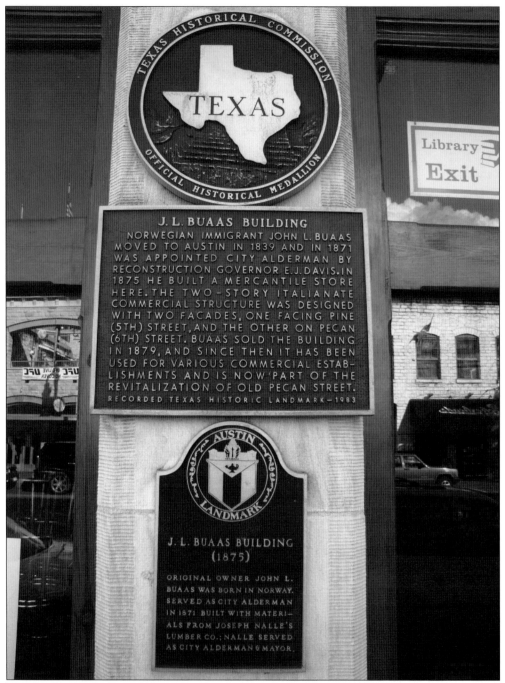

This historical plaque commemorates Norwegian immigrant J. L. Buaas. He built the present structure 15 years after Buaas Gardens was the entirety of the 400 block. Mirrored on the right from across the street, the Kriesle Building stands watch on Sixth as it has for 150 years. (Courtesy of Ozgur Cakar.)

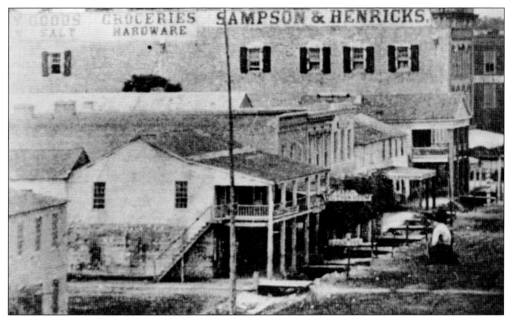

This is the earliest photographic image of the Bullock Hotel at Pecan Street and Congress Avenue. Comparing it to the 1840 bird's-eye view of the city, this new structure appears to have been built in front of the original and now faces a well-defined, rapidly developing Congress Avenue. Still unpaved, the slightly elevated walkways cross the street to little bridges over the drainage ditch. The stagecoach stopped here from 1845 until the trains came a quarter century later. Note the covered wagon parked in front of Carr's Auction Room and the Sampson and Hendricks four-story building advertising a most precious and life-sustaining commodity we all take for granted now but cannot live without—salt. (Courtesy of Austin History Center.)

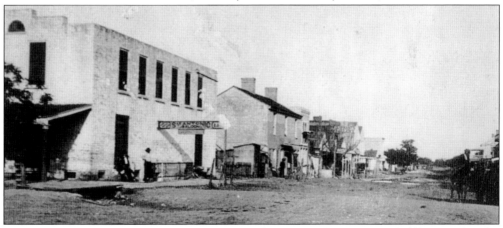

The San Antonio Saloon in this 1868 photograph occupies the first stone building in the city, built at Pecan Street and Congress Avenue by Ziller in the late 1840s. On a July afternoon in 1865, slaves and their masters ran up Pecan from the market, summoned by the cannon fire of Merritt's Union soldiers marching down Congress toward the river, firing 36 cannon barrages to assemble the citizens. Travis County sheriff Thomas Collins read Maj. Gen. Gordon Granger's order number 3, issued in Galveston on June 19, 1865: "The people are informed that, in accordance with a proclamation from the executive of the United States, all slaves are free." (Courtesy of Austin History Center.)

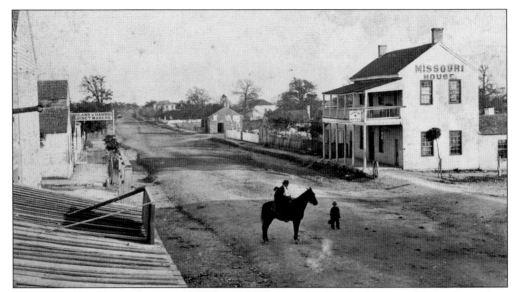

The south side of Pecan Street in 1866 shows the Austin Hotel at the Missouri House, the earliest structure at Pecan and Brazos Streets. Built by German businessman Michael Ziller for his family of eight around 1844, it was later famous as a gambling hall, tavern, and hotel for weary travelers who got off the stagecoach. If a passenger died en route, cabinetmakers and undertakers England and Hannig were conveniently located across the street. On horseback is a man named William Oliphant, the first jeweler on Pecan Street, having opened his shop in 1852. (Courtesy of Austin History Center.)

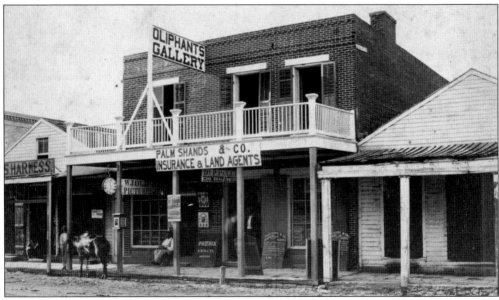

By 1877, jeweler Oliphant has a two-story brick building at 120 East Sixth Street, which housed a number of businesses, including Dr. P. P. Clup, homeopath. Next door, a man made pictures and displayed his photographs in a box attached to a supporting beam in front. Harness makers and insurance and land agents round out a cluster of businesses, which would all meet the wrecking crew in eight years, when Jessie Driskill laid the cornerstone of the historic district. (Courtesy of Austin History Center.)

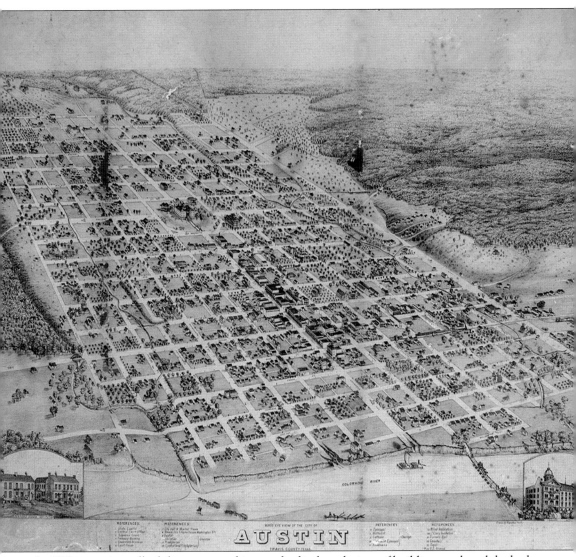

In 1873, an artist walked the streets making methodical renderings of buildings as though he had soared above on the wings of a great bird. Note the wagon train plodding across the Colorado River at the mouth of Shoal Creek. Here the first cattle drive up the Chisholm Trail from Mexico crossed the river and then East Avenue on the long trek to Kansas. The Houston and Texas Central Railroad chugs in from the east, bringing fresh food from the coast but, sorry, no room for cows. The arrival of the railroad in 1871 began the exuberant development of the Sixth Street Historic District. (Courtesy of Austin History Center.)

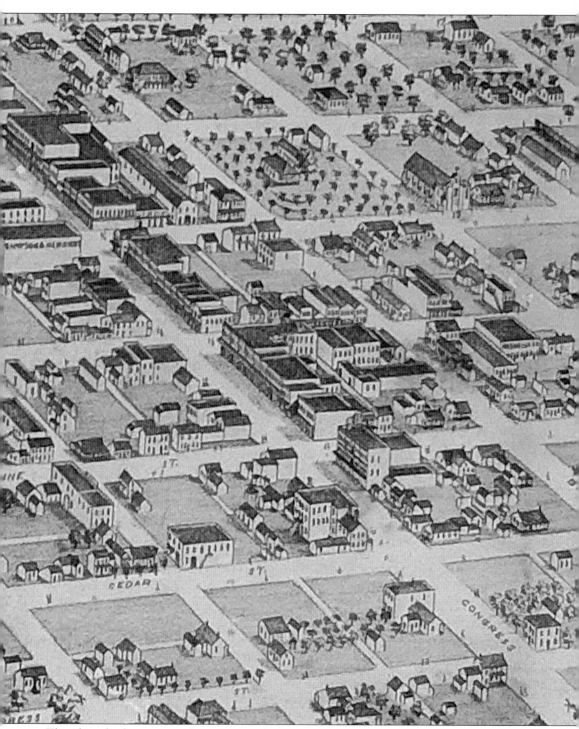

This clever bird's-eye view of 1873 Austin shows the Bullock Hotel at Pecan Street and Congress Avenue, and across the street, the first stone building in Austin is a quarter of a century old. Undertaker Hannig's building in the 200 block looks as it does today. Mathias Kriesle would make patrons a cabinet or a casket at 400 Pecan in a building already 13 years old. In time, this venerable structure would house

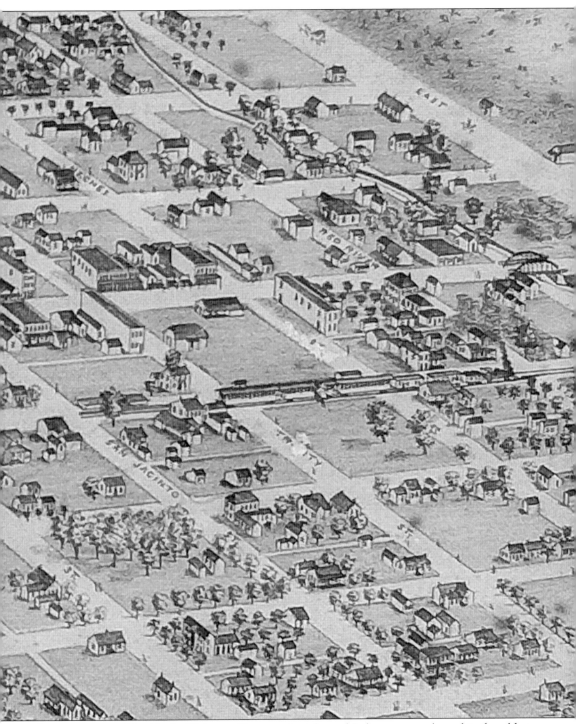

businesses owned by black, Chinese, German, Jewish, and Lebanese people and is the oldest surviving building in the historic district. Across the street, at Pecan and Trinity Streets, Smith has completed his tinware, dry goods, and grocery store, where the present-day rock and roll of Maggie Mae's bursts upon 21st-century Sixth Street. (Courtesy of Austin History Center.)

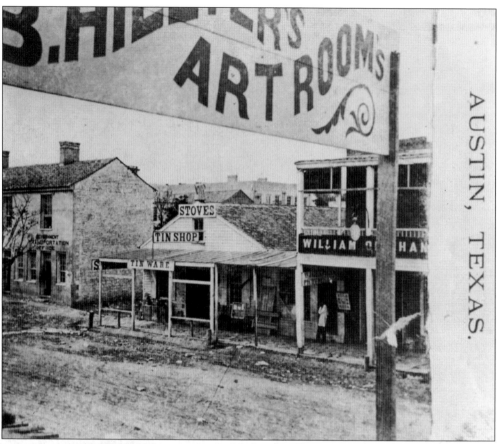

STOVES

TIN SHOP

TIN WARE

WILLIAM

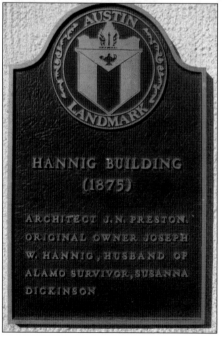

AUSTIN
LANDMARK

HANNIG BUILDING
(1875)

ARCHITECT J.N. PRESTON.
ORIGINAL OWNER JOSEPH
W. HANNIG, HUSBAND OF
ALAMO SURVIVOR, SUSANNA
DICKINSON.

Undertaker Hannig now has a two-story place, with a porch upstairs for boarders to have tea and stroll about. Hannig was the fifth husband of Susanna Dickinson, the only Anglo survivor of the Alamo massacre. She ran the second-story boardinghouse, while the first floor was the cabinetmaker's shop. Like Pecan Street fellow craftsman Mathias Kriesle, he also made caskets. The windowless, black "death cart" would pick up the deceased at their house and, as there were no funeral homes, deposit the body at Hannig's for a casket fitting. The Austin Ghost Tours tell of the sightings of a homely old lady in a white dress who keeps closing doors upstairs in the historic Hannig building. Maybe Susanna did not like guests leaving their doors open? (Courtesy of Austin History Center.)

Cabinetmaker and undertaker Hannig built this structure to last, and it has done so for 135 years. It was home to Austin's first JCPenney store and many furniture establishments at 204 East Sixth Street. (Courtesy of Ozgur Cakar.)

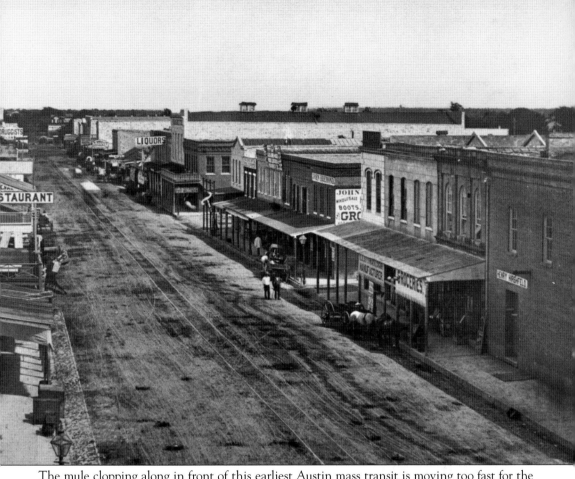

The mule clopping along in front of this earliest Austin mass transit is moving too fast for the camera of 1875. Railroad traffic had so congested Pecan Street, city fathers paved the street in red brick, with tracks running up to Congress Avenue. In 1874, the first two tries to round the corner at Congress toppled the trolley. Henry Hirshfeld's third haberdashery on Pecan is at right in this picture. Notable merchant John Bremond sold everything from boots to groceries in the half a block he owned from the alleyway to Brazos. Across the street, a milliner has opened on the corner where, half a century later, Gellman's sold dresses for proms and suits for "marryin' and buryin'" for 60 years. (Courtesy of Austin History Center.)

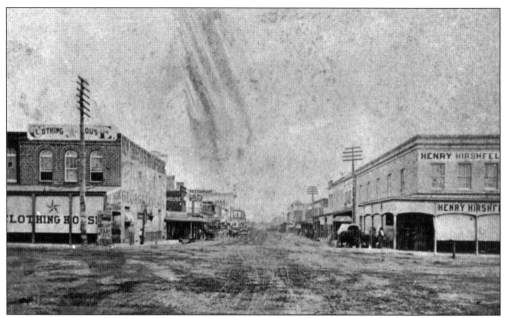

Sixth Street has telephones and electricity, and merchant Hirshfeld has made it to the avenue. The 15-year-old Polish youth who landed in San Francisco in 1854 now owns prime real estate at Sixth Street and Congress Avenue. He will soon build and own the Austin National Bank. Above this store, in the Odd Fellows Hall of 1876, Henry Hirshfeld and Phineas de Cordova held the inaugural meeting of Temple Beth Israel, Austin's first Jewish congregation. The historic Hirshfeld mansion at Ninth and Lavaca Streets reminds people of this positive, moving force of 19th-century Pecan Street and what one determined man can achieve. (Courtesy of Austin History Center.)

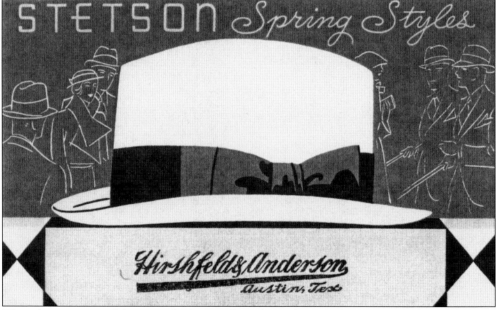

This advertisement of the 1920s for Stetson hats shows the upscale nature of the Hirshfeld and Anderson Store on Congress Avenue. (Courtesy of Austin History Center.)

Perhaps inspired by America's first female superstar, Annie Oakley, Stetson begins making (and Hirshfeld begins advertising) Stetson hats for ladies. (Courtesy of Austin History Center.)

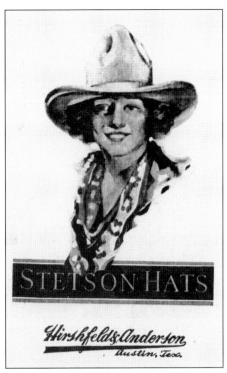

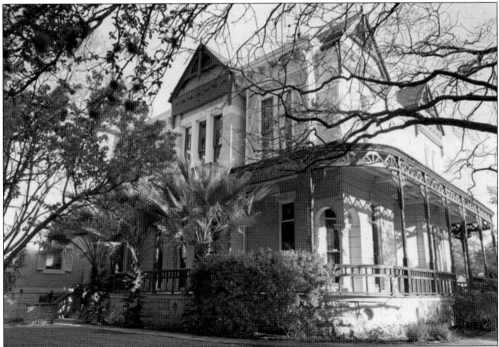

This elegant mansion at Ninth and Lavaca Streets is left to posterity as the Hirshfeld-Moore House. Headquarters for the Office of Government Relations at Texas A&M University's Austin branch, its Victorian-age grace was captured in this recent photograph. (Courtesy of Michael Kellett Professional Photography.)

Ex-Confederates Paced 6th Street

By HAMILTON WRIGHT
Written Especially For
The Austin American

At turn of this century West Sixth Street was the "patrol of ex-confederate soldiers going to and from their State home far out on that street.

Not one here and there—but a whole troop of them.

They were proud of their gray uniforms. And they were loquacious as a nagging amazon at breakfast. Some of them wore badges denoting bravery on the battlefield.

They walked from the home to town. Some of them were peddlers. From their weekly ration of BattleAxe Chewing tobacco, Duke's Mixture and Bull Durham they peddled at "discount" rate in order to get a few pennies to buy something more useful.

At some benches along West Pecan (now West Sixth Street), under shades resting or ventilating or waiting for an electric trolley, a small group of them might be seen and heard. They were gesticulating and raising their voices with all the vigor and determination of battle, reminiscing on their daring and gallantry in Bull Run battles. They still fought against the Yankees—and with verbal fierceness. More than one told this then youthful writer, "Young man, you'll see the day when they'll go to war again—and we'll whoop them good."

And many of these old warriors bore evidence of the atrocities of the War Between the States. One was on crutches, a leg gone; another held the stump of an arm; others had long, white scars blazoned hideously across smiling faces. None of them would admit he had fought for an "unjust cause."

"No sah! We didn't fight to keep colored folk slaves," one said high-voicedly. "We fought to preserve states rights."

Most of the old soldiers had

come from homes where slaves were kept and some of them were proud to tell you Aunt Lucindy (a Negress slave) had nursed them when infants.

"It ain't the Negro we hate," one told me once. "It's them damn Yankees!" Judging by the way he said that, he evidently went to his grave unchanged in his opinion and animus.

Many a time I bought my scant tobacco wants from these old boys. The price was about half that charged in stores. And the tobacco was fresh. And the old Confeds thanked you like a Carolina "kunnel", too.

That brave cloud of witnesses to the Civil War lies beneath the sod in many a graveyard all over the world, not forgotten but their memories and the glorious battles they fought in fresh in our minds through their history. It is indeed a tragedy of the writing fraternity that they neglected to listen closely to their wonderful stories of the battlefield and to record them for their descendants to read and ponder.

Many of their sons and daughters too are descending the hill to the common destination of humanity. But the principles these warriors instilled in them and the memories of the stories they told of hardship—starvation, hunger, wounds, maltreatment, will remain for another decade or two Then the curtain that gives a final peep will be lowered and all then that will be known of the terrible days of 1860's, with its subsequent "carpetbagger" atrocities, will be found in doctored histories.

The monuments erected in Austin will silently bear witness to the monster episode that rifted the United States and left wounds that are festering anew this year.

Meanwhile, the spirits of tobacco-peddling, gray-clad Confederates still move silently and aimlessly up and down West Sixth Street.

This sympathetic article about the old Confederates appeared in the *Austin American* in 1963. They lived in the Confederate Home for the Aged on West Sixth and would don their tattered uniforms and parade as a group down Sixth. They called the Civil War the war between the states, and said, vis-à-vis the slavery issue, "It ain't no Negro we hate, it's them damn Yankees!" (Courtesy of Austin History Center.)

Trolleys were electrified, as seen in this early 1890s shot looking up West Sixth. Pecan Street had become Sixth in 1884, when the city's expansion had run out of the native tree names they used for the first 14 east–west blocks. Bois d'Arc Lane was lost to Seventh Street, and Peach Street morphed into Fifth Street. Old Confederates would proudly march down to East Sixth, where they would sell their extra "gubmint t'bacci" to former slaves, who were glad for the cheap smokes. Upon hearing this story, Stuart King (King-Tears Funeral Home) quipped, "Yeah, Sixth Street's first drug deal!" (Courtesy of Austin History Center.)

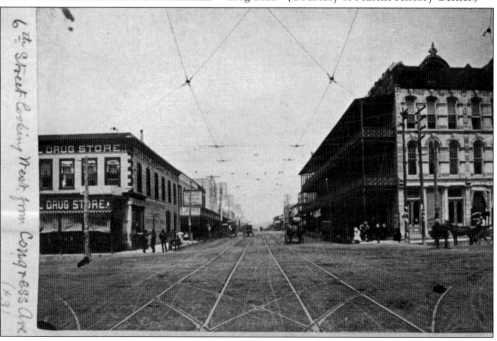

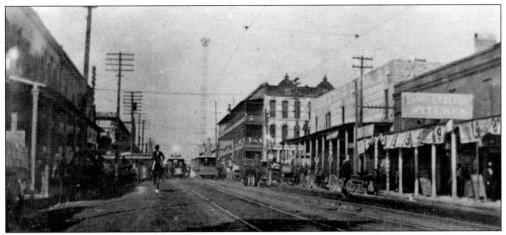

The three-story Bullock Hotel at Sixth Street and Congress Avenue has a new coat of paint and south-facing balconies that invite guests to feel the bustle of the street and hear the clang of the trolleys. Most significantly, in this late 1880s picture, a 165-foot Artificial Moonlight Tower rises at Nueces and Sixth Streets. Illuminating a 1,500-foot radius brightly enough "to read a watch," the towers were erected in the shape of a star (if seen from the air), and they had their own electric generators near present-day Tom Miller Dam. Intended to make neighborhoods safer, 17 of these unique moonlights continue to brighten Austin and are protected landmarks listed in the National Register of Historic Places. (Courtesy of Austin History Center.)

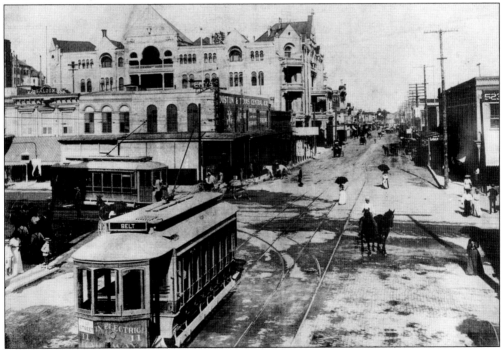

This is a view of the Sixth Street masterpiece of Victorian grandeur, the Driskill Hotel, that we shall never see again. Completing it in 1886, Col. Jessie Driskill had, by the 1890s, lost the grand hotel in a card game. There are no automobiles, but pedestrians have to stop when *Beltline*, of the Austin Electric Railroad, lumbers up Sixth. Note how well dressed everyone is, even the youngsters (on the left) sporting straw hats. (Courtesy of Austin History Center.)

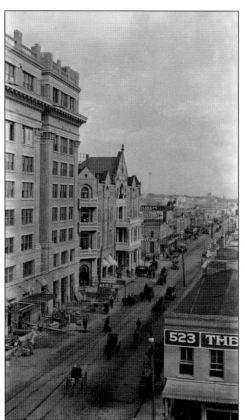

It is 1911 and banker George Littlefield has built Austin's first financial center, shown here in its final stages of completion. In 1871, Littlefield rounded up 600 head of cattle and personally bossed the first cattle drive up the legendary Chisolm Trail that crossed the Colorado River at the mouth of Austin's Shoal Creek. Not yet installed in this picture, 2.5-ton brass doors would open to Littlefield's American National Bank. Autos now dot the street, seeming to mix comfortably with horse-and-buggy rigs. Sixth Street always had a place for everybody. (Courtesy of Austin History Center.)

The cornerstone of Sixth Street for 125 years, the Driskill Hotel is believed by many to be the most elegant structure ever built in Austin. Before the start of the 20th century, cattle baron and banker Col. George Littlefield became the hotel's fifth owner. He paid $106,000 cash and spent an additional $60,000 to install such upgrades as steam heat and electric fans and lights. When this picture was made, a spa had opened, with electric baths supplied by the hotel's own artesian wells. (Courtesy of Driskill Hotel.)

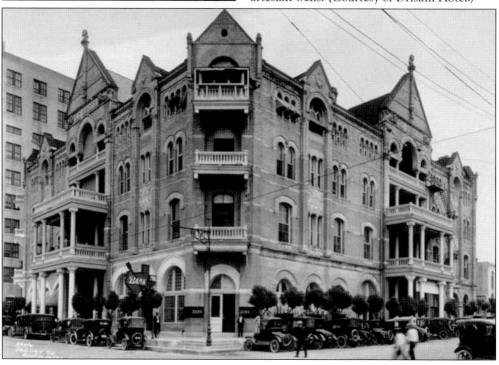

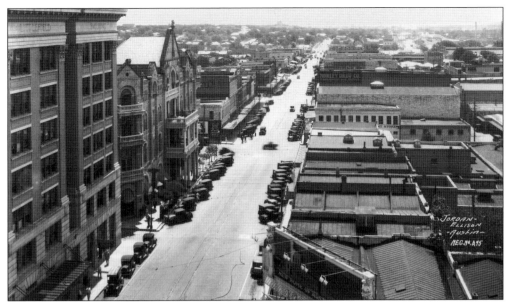

The Roaring '20s found Sixth Street vibrant and fully engaged in the exuberance of the age. The horse and buggies are gone, but they will be back three quarters of a century later as elegant coach tours of historic Sixth Street. Note in this picture shot from atop Scarborough's (southwest corner of Sixth Street and Congress Avenue) that all buildings have awnings reaching to the curb. The 21st-century master plan for a revitalized "Street of Dreams" resurrects the awnings to shade the planned 18-foot sidewalks from the relentless Texas sun. (Courtesy of Austin History Center.)

Louis and Lillian Laves opened their mom-and-pop jewelry store at 211 East Sixth Street two months before the stock market crashed in 1929. They had small children, Pacey and Bernard, whose care was sometimes entrusted to Les Dorn, the African American projectionist at the Ritz Theater. Les would sometimes babysit Pacey as he ran the projector. A Lebanese family, the Gilletts, had a cot for their son Robert, and three-year-old Pacey would hop in for a nap. This reciprocal altruism, one hand washing another, was characteristic between races and the ethnic merchants of East Sixth. (Courtesy of Pacey Laves.)

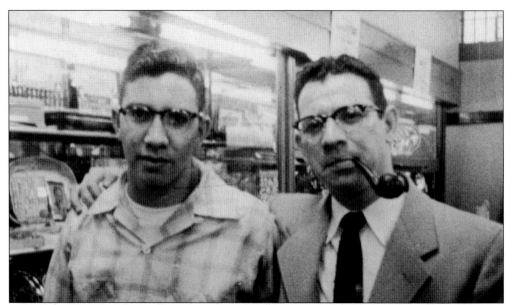

Harold Pacey Laves (left) and older brother Bernard appear here in their 1950s jewelry store. Both would carry on the 78-year family business as Benolds Jewelers. (Courtesy of Pacey Laves.)

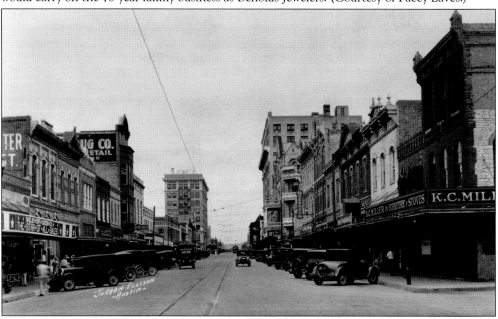

The Great Depression was a few months along when this photograph was taken looking west from San Jacinto. JCPenney's first store in Austin is on the right in what is now the historic Hannig building. Austin's first H. E. B. Grocery Store (then called H.E.Butts, the owner's name) was at 600 East Sixth Street, and Academy Stores (now 49 in number) started on Sixth as Academy Army Surplus. Tucked in next to Shelby Dry Goods is the small mom-and-pop jewelry store Laves (later renamed Benold's), which had opened its doors in 1929 on the eve of the crash of the world's economies. But Sixth Street did not crash, and for the next three quarters of a century, the Laves were trusted jewelers and dear friends of the street's other mercantile families. (Courtesy of Austin History Center.)

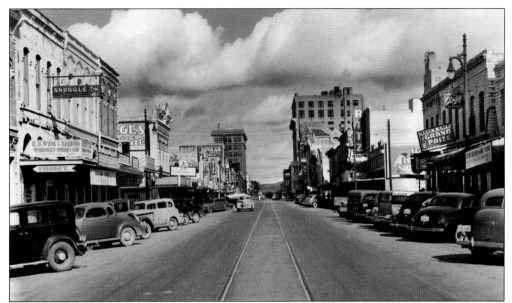

It is the eve of World War II in this shot looking west from the 400 block. The abandoned trolley tracks go nowhere, like the lives of many persons set adrift by the Depression. The rails were torn up and sold for scrap iron for $10 a ton at the onset of the war. J. J. Hegeman's Ritz is 10 years old now and is the only downtown theater that will admit African Americans, though they had to sit upstairs. Note the post-prohibition reappearance of taverns, like Isaac's Café with its Schlitz beer sign and the U.S. Wine and Liquors. These were owned almost exclusively by Lebanese and Jews, who gradually replaced the 1920s' thriving community of black entrepreneurs of East Sixth. (Courtesy of Austin History Center.)

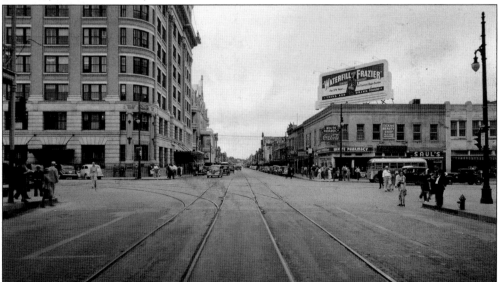

In this picture, shot east from Congress Avenue, a light-colored car waits at the corner, always the invisible line between earthy East Sixth and the gentrified avenue. African Americans did not receive equal treatment on Congress Avenue, and some stores would not hire Jews. But in the segregated society of the 1950s, Sixth Street was the standout exception. (Courtesy of Austin History Center.)

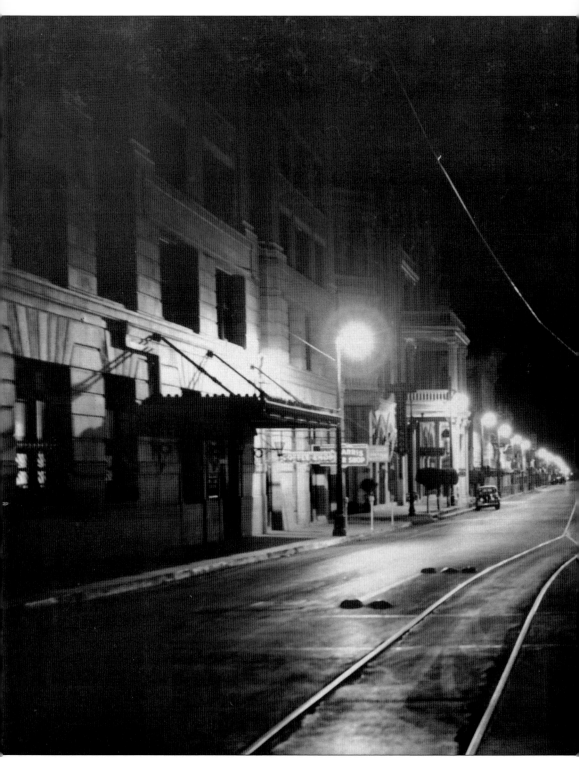

Historic East Sixth has been called The Street of Dreams. This Depression era photograph shows the 60-year-old trolley tracks with electric lines above. A rain has cleared the streets. For 170

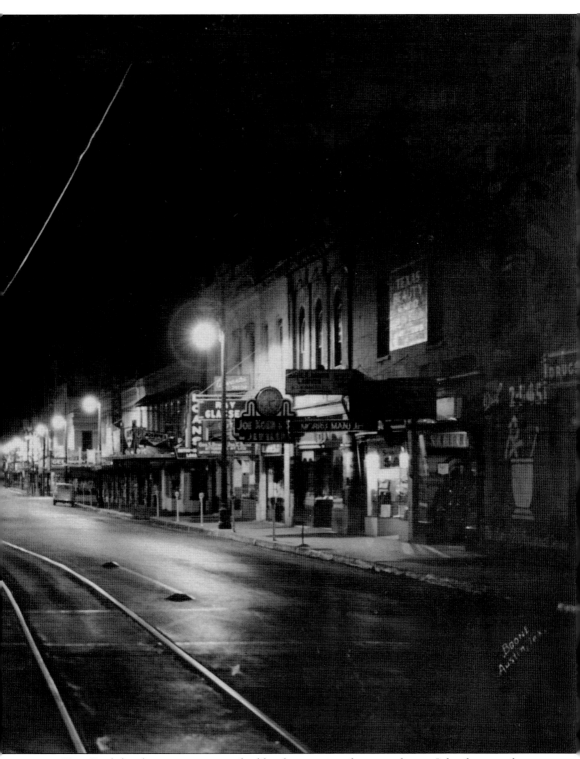

years, East Sixth has been a river nourished by the streams of many cultures. Like these tracks, their dreams intertwine. (Courtesy of Austin History Center.)

The war is on, leaving merchants like Sol Ginsburg (Saul's, page 31) scrambling for goods to sell to people buying everything in sight. The adolescent sons of the Sixth Street merchants of the 1950s called him "Leetle Soli," poking fun at his "heck-cint." His patter to customers was frequently imitated. "A very lovely pant—the finest moichendize!" A block away, World War II found John Hurwitz's Army Navy Store so engorged with Levi's that he made a fortune by the war's end. Unfortunately, he continued to buy prodigious quantities of jeans *after* the war, until walking in the store was to drown in a sea of blue denim. (Courtesy of Michelle Ginzburg Chasnoff.)

Maybe the steel from these torn up tracks made tanks during the war. Gellman's has thrived at Sixth and Brazos Streets for nearly 20 years, a far cry from founder Dave Gellman's arrival in America without enough money to buy a newspaper. Note Stillman's Photo Store and the colorful awnings at the Driskill Coffee Shop. All the cars are from before 1941, as there were none made during the war. (Courtesy of Austin History Center.)

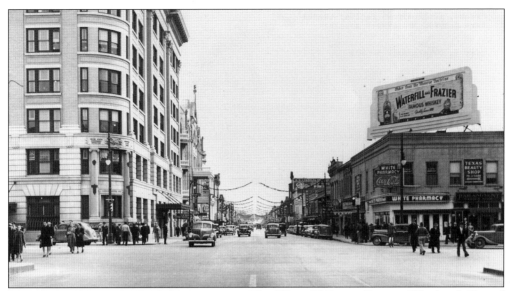

Now the tracks are gone and the war is over. The Waterfill-Frazier Famous Whiskey billboard seems incongruous atop White's Pharmacy. The soda fountain at White's rang with the chatter of short-order cooks: "That'll be two bums on a raft, burgers a pair on wheels, and draw one in the dark," which translated to two poached eggs on toast, two hamburgers to go, and one black coffee. Strands of yuletide decorations seem to meet at an invisible point down the middle of East Sixth, as did the many cultures and ethnicities of the street. (Courtesy of Austin History Center.)

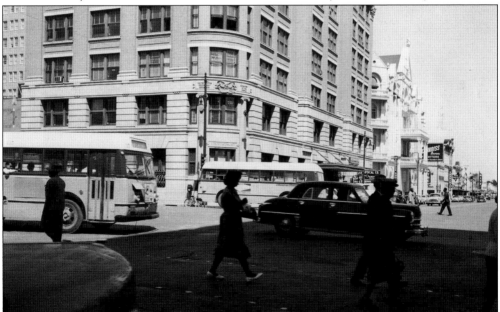

On the graceful, rounded corner above the American National Bank entrance is inscribed "United States Government Depository—Depository of the People." Next door is the early 1950s Driskill Coffee Shop, where they made yummy cheese soup that is still being served by their authentic period piece, the 1886 Café and Bakery. The buses had no air conditioning, so passengers just hung out the open windows and hoped the diesel fumes were blowing the other way. (Courtesy of Austin History Center.)

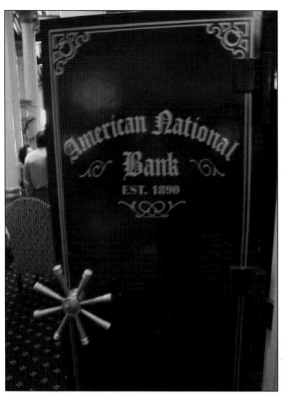

This bank vault was left in the lobby of the Driskill Hotel, where George Littlefield had his bank for two decades. (Courtesy of Ozgur Cakar.)

East Sixth was beginning to show decay, as can be seen in this picture looking west from the 700 block in 1959. The building of Austin's first freeway, I-35, was nearing completion along East Avenue. This created an unfortunate barrier from black and Hispanic east Austin, then the lifeblood of East Sixth. An *American Statesman* article a few years earlier noted: "All are waiting. Waiting for a friend, a live one, or a job; Maybe a drink, or just an idea. There's a lot of waiting on the *Street of Broken Dreams*." (Courtesy of Austin History Center.)

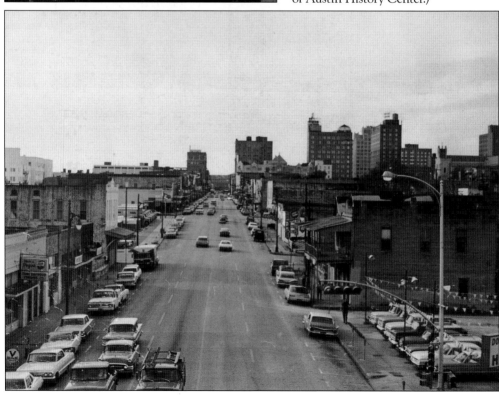

Two

THE DREAMS OF MANY CULTURES INTERTWINED

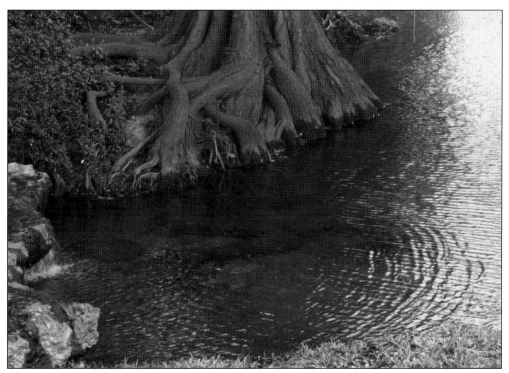

This centuries-old bald cypress grows unmolested from Waller Creek. Its intertwining roots, like the many cultures of the historic district, dive into the Blue Hole, where children of all races swam for a century. (Courtesy of Ozgur Cakar.)

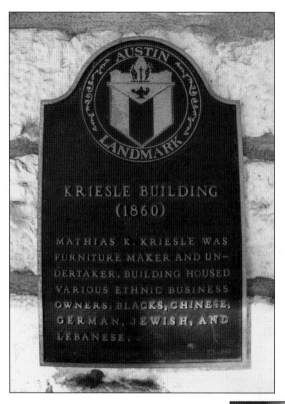

Pecan Street became a business powerhouse with the arrival of the railroad in 1871. The bustle of traffic soon required the street to be paved with brick. Tracks were from East Avenue (now I-35) to Congress Avenue for Austin's first mass transit, a mule-drawn trolley. Pecan Street was always a blended commercial district. By 1872, a shopper could buy "fancy groceries" from Austin's first black property owner, Ed Carrington. In that same 500 block, Austin's first Jew, Phineas de Cordova, owned two lots. A block away, road builder and surveyor for the Republic of Texas Benjamin Risher had built what would become the oldest surviving structure in the historic district at 400 Pecan Street (the Kriesle Building). Thus began the intertwining of the dreams of many cultures, as the historical citation records: "This building housed various ethnic business owners: Blacks, Chinese, German, Jewish, and Lebanese." (Courtesy of Ozgur Cakar.)

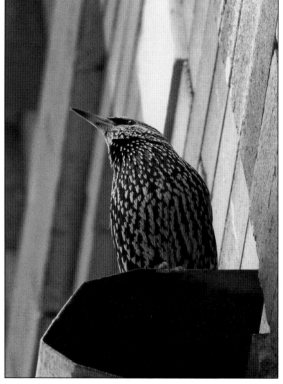

The intermingled black and white of the European Starling's breast is like the blend of races and cultures on East Sixth. Starlings spend their nights in large communal roosts and are sometimes considered a nuisance, but there's always a place for everybody on the Street of Dreams. (Courtesy of Ozgur Cakar.)

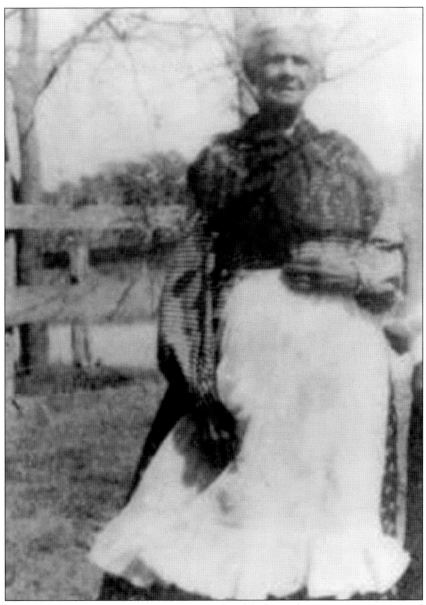

Mahala (ma-hail`-e-ya) Murchison was Austin's first black resident, arriving in 1839 when the Murchisons lumbered up Pecan Street in their ox-drawn wagon. They were greeted by the only other person here, Jacob Harrell, then finishing the first cabin built in the newly named capital. Upon seeing Murchison, he realized she was about to deliver her third child and said, "Take my cabin. Take it and live there." And fortunate it was they accepted this first act of goodness, as that night, Austin's first baby was born. Slave girl Mahala was 10 and was so devoted to the family that she refused to be freed. A white man named Strain fell in love with her and wished to purchase her for the purpose of marriage. She was taken with him but declined marriage and freedom, though she would come to bear him six children. The children were not slaves, and several became teachers. Interestingly, Mahala was the granddaughter of an Indian chief and the daughter of a white man. Thus, our first black citizen was white, black, and Native American. That's Austin for ya. (Courtesy of Carver Museum.)

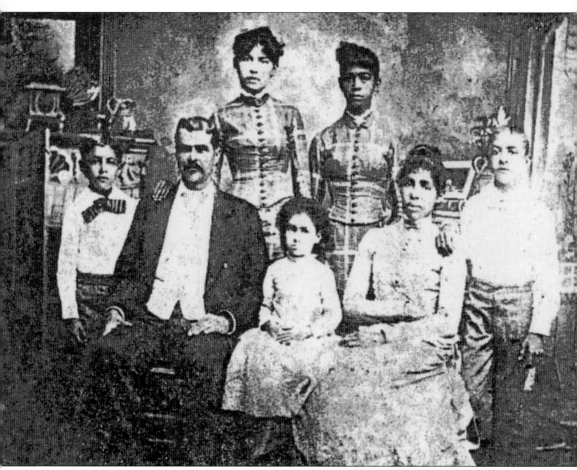

Mahala Murchison's son is pictured here with wife, two sons, and three daughters. Mahala's children, whose father was white, were free, and two of her daughters became teachers. (Courtesy of Carver Museum.)

Souvenir Book
Exhibition
November 14, 1986 - May 31, 1987

Sixth Street

The
Image of
The Black
Entrepreneur

CARVER MUSEUM
1165 ANGELINA
AUSTIN, TEXAS 78702

Austin's black history museum, the George Washington Carver Center, produced a stunning exhibit and publication entitled *The Black Entrepreneurs of East Sixth Street*. The most prominent of the entrepreneurs were characterized not only by their mercantile or professional success but as general benefactors of their people. Between 1872 and the 1920s, black enterprises thrived on East Sixth, clustering on the north side of the 400 and 500 blocks. JJ Drugs was a medical/dental/pharmaceutical consortium that included druggist Jennings, the African American physicians Stevens and Abner, and remarkable civic leader and dentist Everett Givens. (Courtesy of Carver Museum.)

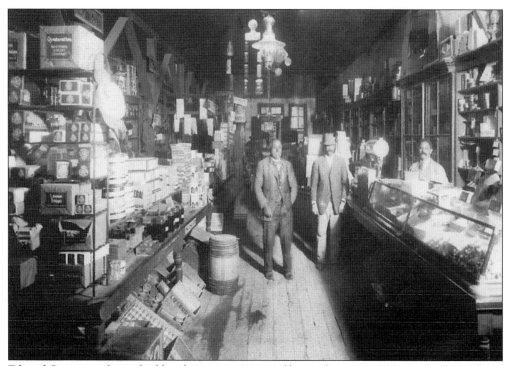

Edward Carrington began building his grocery store and home above it in 1872. His brother, Albert, owned the blacksmith shop behind the store and was elected city alderman in 1882. Navigating the complex land laws of the time, Ed Carrington became Austin's first black property owner. He purchased the empty lot at 518 Pecan Street for $200. Not content to be simply a successful rancher and grocer, he responded to his community's needs by organizing the Friends in Need Committee, which arranged for the burial of impoverished blacks. He loaned money to families to buy farms and gave food to the destitute. Curiously, the 1880 U.S. Census lists Carrington's race as "mulatto," and his wife was most certainly white. Thus, Sixth Street's first African American mercantile family was multiracial. (Courtesy of Austin History Center.)

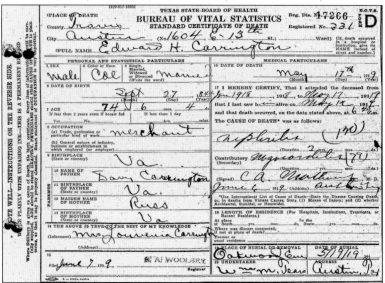

Edward Carrington (1844–1919) died a successful man at 74 years of age. Curiously, his death certificate lists a different mother and father for him than his brother, Albert. (Courtesy of Martin Hale.)

Former alderman and blacksmith Albert Carrington appears to have died with the same diagnosis as his brother, Ed. Both have nephritis listed as the cause of death. (Courtesy of Martin Hale.)

The Lyons family enjoys their car. In 1912, they were the first black family in Austin to own an automobile. They also owned a horse and wagon. In times of racial unrest, the Lyons family would hide people in barrels and put them on the wagon under a pile of hay. The children would jump on top, start singing songs, and pretend they were having a hayride. (Courtesy of Carver Museum.)

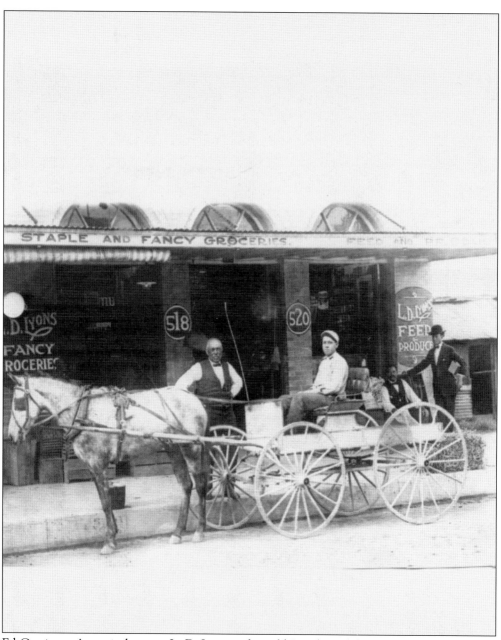

Ed Carrington's son-in-law was L. D. Lyons, who sold "staple and fancy" groceries and was a champion for the rights of his people. Successful and prominent, he is shown here in front of the store with his son at the reigns. Lyons was remembered by the *American Statesman* (November 1944) as having "done more to promote good will between the races in Austin than any other negro." The obituary did not mention that L. D. Lyons was the acknowledged son of Texas governor Elisha Pease. Daughter Eunice Lyons Prescott remembers being taken to the capital, where their grandfather Pease would give them a kiss and stuff a little money in each of his grandchildren's pockets. The Carrington-Lyons family was in business on East Sixth Street for a century. (Courtesy of Austin History Center.)

This beautifully restored 1872 Victorian building was erected by Austin's first black property owner, Edward Carrington. He was also a general benefactor for his people, Austin's first black merchant prince. (Courtesy of Ozgur Cakar.)

This Carrington 6 group of design consultants, aware of the historical significance of 518, is responsible for the immaculate restoration of the first black-owned building in Austin. (Courtesy of Ozgur Cakar.)

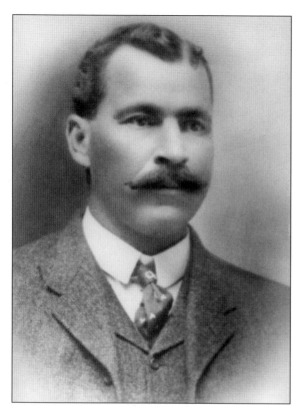

The first black funeral home in Texas was opened by William Tears at 514 East Sixth in 1901. African Americans faced hard economic times then, with the cost of living doubling but their wages remaining unchanged. Vagrancy became a problem on Sixth, so to counter this developing culture of poverty, Tears organized and operated the Vocational Welfare Committee. Tears kept this office at 514 East Sixth open 24 hours a day, assisting the unemployed with funding and job opportunities. He merged his funeral home with the King family to become King-Tears, still in operation 110 years after William Tears first dug into the east Austin earth to give African Americans dignified endings. (Courtesy of Marjon Christopher.)

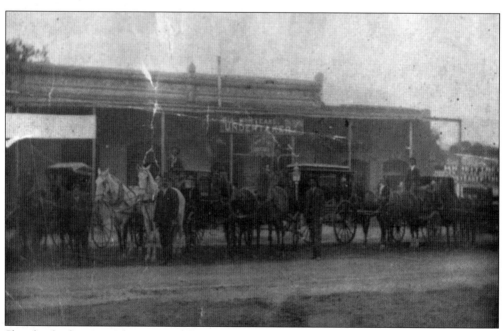

Shortly after beginning business, William Tears acquired this property at 614 East Sixth to continue his first African American funeral home in Texas. The processional equipment was dignified, as were the services Tears provided. (Courtesy of Marjon Christopher.)

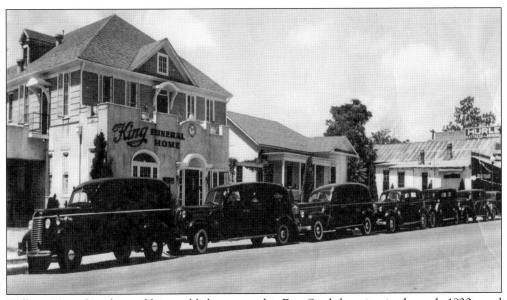

William Tears Sr. relocated his establishment to this East Sixth location in the early 1920s, and in 1955, his son merged the business with the existing King Funeral Home to become King-Tears, now serving the Austin community in its 111th year. (Courtesy of Marjon Christopher.)

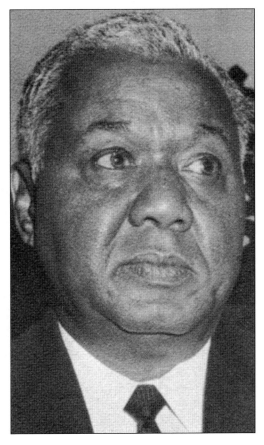

The last decades of the 19th century until the 1940s saw Sixth Street become home to 17 trades and professions practiced by African Americans. The Carver Center of African-American History produced an exhibition in 1981 entitled The Black Entrepreneurs of East Sixth Street. Shown to the right is Dr. Everett Givens, Austin's most prominent black dentist, whose practice in the Ebenezer Building (421) included people of all races, opening there in 1910. Everett Givens, D.D.S., was a tall, handsome man with a refined manner who fought for equal pay for equal work in Austin city jobs and improved educational opportunities. Givens owned the Lyric Theater on Sixth, Austin's first black movie house, which also hosted live entertainment. He founded the *Community Argus*, a newspaper still being published 100 years later. Dr. Givens had close relationships with the compelling political figures of his day: Mayor Tom Miller, Speaker of the U.S. House of Representatives Sam Rayburn, and Pres. Lyndon B. Johnson. Givens Street in Austin and the E. H. Givens Recreation Center on East Twelfth Street remind people of his lifelong service to his community. (Courtesy of Carver Museum.)

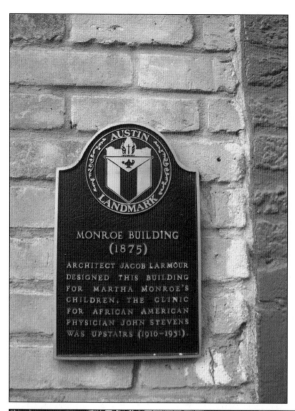

The historic Monroe building, at 300 East Sixth, was the office for Austin's first and most prominent African American physician, Henry Stevens, M.D. (1893–1931). Imagine his patients' fright should they see it today; a nightclub, one of about 55 on Sixth, it sports a 6-foot wooden mask whose gaping mouth promises to swallow the unwary. (Both, courtesy of Ozgur Cakar.)

This 500-year-old Cedar of Lebanon symbolizes the resilience of the Lebanese people, as in Psalm 92:12, "The righteous shall flourish like the palm tree; He shall grow like a cedar of Lebanon." (Courtesy of Eve Cakar.)

Lebanese businesses clustered near this intersection after Michael Daywood dared to build on the unpredictable Waller Creek. (Courtesy of Ozgur Cakar.)

1. PLACE OF DEATH
STATE OF TEXAS

COUNTY OF Travis

CITY OR PRECINCT NO. Austin, — 803½ East Ave.
GIVE STREET AND NUMBER OR NAME OF INSTITUTION

2. FULL NAME OF DECEASED — Mrs. Mary Hello

LENGTH OF RESIDENCE WHERE DEATH OCCURRED 46 YEARS MONTHS DAYS (SOCIAL SECURITY NO. None

RESIDENCE OF THE DECEASED STREET AND NO. 806½ East Ave. CITY Austin, COUNTY Travis STATE Texas

PERSONAL AND STATISTICAL PARTICULARS | **MEDICAL PARTICULARS**

3. SEX Female | 4. COLOR OR RACE White

17. DATE OF DEATH November 2, 1940 194

5. SINGLE, MARRIED, WIDOWED OR DIVORCED (WRITE THE WORD) Widowed

18. I HEREBY CERTIFY THAT I ATTENDED THE DECEASED FROM *March 12* 1940, to *June 4* 1940
I LAST SAW HER ALIVE ON *March 12* 1940

6. DATE OF BIRTH February 16, 1862

THE DEATH OCCURRED ON THE DATE STATED ABOVE AT

7. AGE YEARS 78 | MONTHS 9 | DAYS 16 | IF LESS THAN 1 DAY HOURS MIN

THE PRIMARY CAUSE OF DEATH WAS: | DURATION

8A. TRADE, PROFESSION OR KIND OF WORK DONE Housewife

Probably malignang of Live & Gall Bladder

8B. INDUSTRY OR BUSINESS IN WHICH ENGAGED

9. BIRTHPLACE (STATE OR COUNTRY) Mt. Lebanon, Syria

CONTRIBUTORY CAUSES WERE *age*

10. NAME William Hello

11. BIRTHPLACE (STATE OR COUNTRY) Syria

12. MAIDEN NAME Ventura Carom

13. BIRTHPLACE (STATE OR COUNTRY) Syria

IF NOT DUE TO DISEASE, SPECIFY WHETHER. ACCIDENT, SUICIDE, OR HOMICIDE

14. SIGNATURE Joe Joseph

DATE OF OCCURRENCE

ADDRESS Austin, TEXAS

PLACE OF OCCURRENCE

RECEIVED JAN 13 1941 TEXAS
DEPARTMENT OF HEALTH BUREAU OF VITAL STATISTICS

15. PLACE OF BURIAL OR REMOVAL Mt. Calvary Cem., Austin TEXAS
DATE December 3, 1940 194

MANNER OR MEANS
IF RELATED TO OCCUPATION OF DECEASED SPECIFY

16. SIGNATURE Cook Funeral Home Inc.

SIGNATURE *Jas S. Wm* M.D.

ADDRESS 1100 Colorado, Austin, TEXAS

ADDRESS *Austin* TEXAS

20. FILE NUMBER 974 | FILE DATE 12-10 194 | SIGNATURE OF LOCAL REGISTRAR *Harold Wood, M.D. L.H.* | POSTOFFICE ADDRESS *Austin* TEXAS

There are no pictures of this remarkable Lebanese woman, who left her mountain village with baby in arms. Told by the steamship company she would be taken from the port of Beirut to America, she was instead unceremoniously dumped in Cuba in 1912. Having lost her baby during the voyage and unable to speak Spanish, Mary Hello somehow survived by learning to be a hawker. This she continued after immigrating to Austin, where she would lug her large chest filled with goods from home to home in the rural Mexican community. Families invited her to stay with them while she showed her wares to neighbors, and to reward their hospitality, she told them, "Take what you need from my chest." They called her *Maria La Arabe* (Mary the Arab). This matriarch of one of Austin's prominent Joseph families understood a most basic principle of human interaction: sharing builds trust. She would, in time, own rental property on Sixth and a ranch at Red Rock, where she grew peanuts and cotton. Oil stocks she bought in the 1920s are still paying dividends to her descendants. Her closest friends were the Hirshfelds. Mary Hello, great-grandmother of Monsignor Don Joseph Sawyer, was the mightiest cedar of Lebanon. (Courtesy of Martin Hale.)

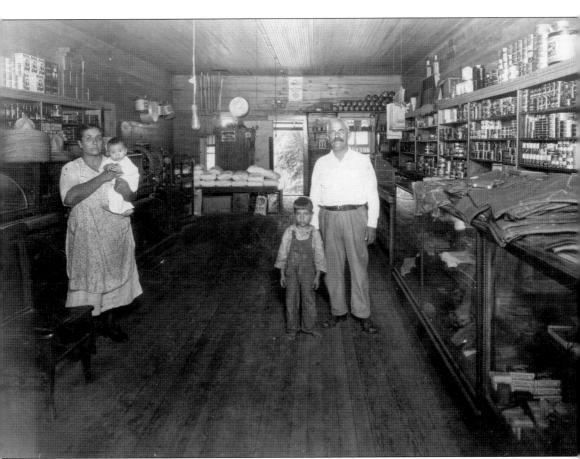

Shown in their earliest store at Sixth and Attayac Streets, Joseph A. Joseph stands with one of his seven sons, who looks a lot like John Greenleaf Whittier's "barefoot boy, with cheek of tan." Sophie Daywood Joseph holds one of their two daughters in this typical early 20th-century mom-and-pop enterprise. Sophie and Joe met on Sixth Street, where their families were in business. One of the three prominent Joseph families in Austin, their descendents include son Bill, who owned the Stallion Drive In on North Lamar (old Austinites might remember their chicken fried steak for one dollar), and Monsignor Don Joseph Sawyer, the spiritual leader of Austin's Maronite Catholic congregation. (Courtesy of Monsignor Don Sawyer.)

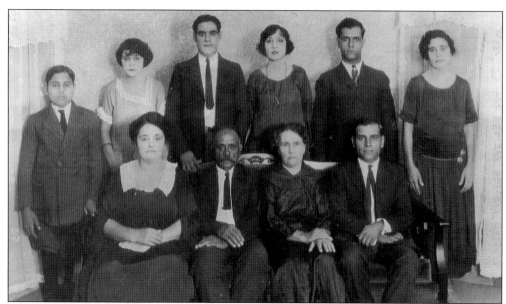

Michael Daywood (center left) peddled from a pack on his back until he could acquire the land on Waller Creek at Sixth, where he built their family compound in the early 1880s. His son, Anthony, stands to the left on legs withered by polio and unable to support his weight without cumbersome braces. At 11, he disgustedly threw them in the creek and, after recounting this to his father, was told, "Fine, then *drag* yourself where you need to go." Tony could raise himself with the prodigious strength of his upper body and learned to walk by locking his knees and swiveling his hips. The Daywoods, like the other Maronite Catholic Lebanese of Sixth Street (the Sheas, Ferrises, Meceys, and Kouris), immigrated from Roumieh, Lebanon. (Courtesy of Carl Daywood.)

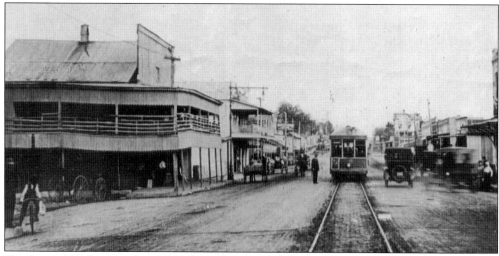

Flooding of Waller Creek in 1901 left the upper balcony of the Daywood family compound sagging a bit, but Michael Daywood sank deep roots on its banks, building resourcefully with discarded cedar railroad ties. His grandson, Carl Daywood (Daywood Realtors, Sixth and Sabine Streets), is the street's true historian and owner of the oldest continuously operated family business on East Sixth Street—120 years. Carl should rightly be considered Sixth Street's unofficial mayor, taking over the 30-year reign of both "Lanky" Laibowitz and Papa Joe Joseph (the JJJ). (Courtesy of Carl Daywood.)

Shown right are Carl and Barbara Daywood, whose Daywood Realty is the oldest continuously family-run business on Sixth. Carl is a historian of the street and has collected a most extensive photographic record of the buildings on it. He should know; he has sold most of them at one time or another. (Courtesy of Carl Daywood.)

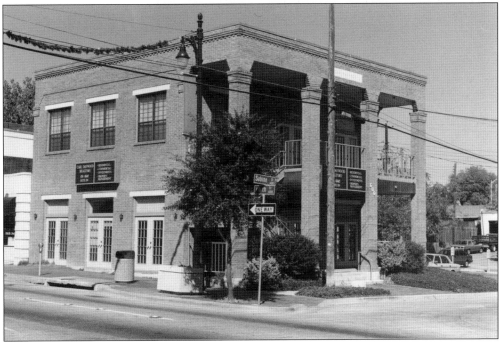

This is the office building Carl built at Sixth and Sabine Streets. Parcels of land near this intersection have been in his family for over 120 years. (Courtesy of Carl Daywood.)

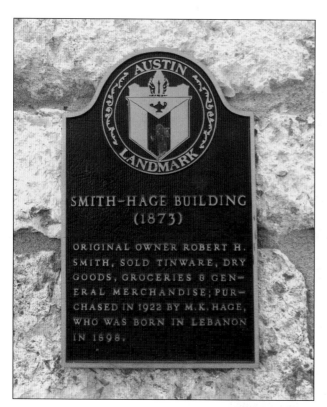

Since the beginning of the 20th century, the Smith-Hage building of 1873 has been owned and occupied by Lebanese. This corner of Sixth and Trinity Streets hosted the Atlantic gardens of the 1870s, which featured Hertzog's Eight Piece Orchestra. It is now a serious blues venue named Maggie Mae's. (Courtesy of Ozgur Cakar.)

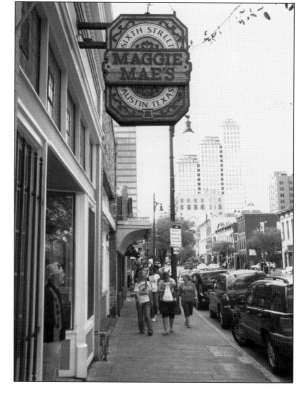

During the 1950s, Maggie Mae's was a hotdog stand, from which a Lebanese man, Bill Shea, produced a unique sauce that turned ordinary dogs into W. C. Fields's tube steaks. His son, William Shea Jr., an architectural engineer and owner of Maggie Mae's, says the recipe for the chili-onion sauce remains a family secret. (Courtesy of Ozgur Cakar.)

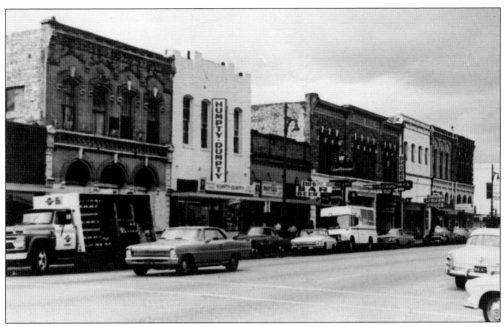

Humpty Dumpty groceries got its name from a contest held by Handy Andy, the original name for the Lebanese Kouri brothers' store. The Kouri family had sold groceries on Sixth since the late 1800s. In the 1950s, the chain store Handy Andy reclaimed their trademark name, and the contest to find a new name was a cliffhanger. Entries such as "The *fRieNdlY* 1," were noteworthy, but the benevolence of Humpty Dumpty won the bag of groceries. (Both, courtesy of Austin History Center.)

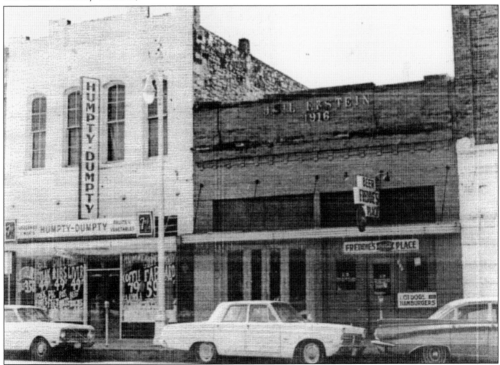

Begun in the early 1900s by pharmacist Elias Ferris, this drugstore was still in operation six decades later, as pictured here. Behind Ferris Drug, at this corner of Sixth and the old East Avenue, is the renowned Tex-Mex restaurant *El Mat*. Druggist Ferris had immigrated from Roumieh in the pine-covered hills north of Beruit, Lebanon. His brother, Anthony, a leading Lebanese intellectual, escaped from Lebanon just ahead of death warrants issued by Turkish authorities. After arriving in the United States, Anthony Ferris undertook the first English translations of Lebanon's most renowned poet and philosopher, Khalil Gibran. (Courtesy of Austin History Center.)

High-energy twins Arthur and Theodore Jabour—along with their mother, Mary Attal Jabour—owned the liquor store above. Interviewed at age 81 by the *American Statesman*, Jabour said they were "one of the families in business on East Sixth Street since anyone can remember." Eldest son Freddy of Freddie's Place, next to Humpty Dumpty, recalled when "the sidewalks of East Sixth were just wooden blocks." In 1981, one of the twins told the *American Statesman* reporter, "We're Lebanese . . . we go back to the Phoenicians, and they were merchants, see? Salesmanship is in our blood." Their sons David and Ralph and daughter Margaret honor their memory with the spectacular success of Twin Liquors. With 61 stores, they seem to be on every street corner. (Above, courtesy of Austin History Center; below, courtesy of David Jabour.)

Papa Joe, as the mayor of East Sixth was called for three decades, was also renowned for playful gunfights with challengers who drifted into Joe Joseph's Triple J Tavern. Called "the fastest gun in the West," he was confronted by Austin's most dreaded hood, Timmy Overton. Into the bar he walks with three of his thugs and their girlfriend, Ida, whom Joe had previously banned. After he refused to serve her, one of their number sidled up to Joe, jabbing a gun into his ribs and saying, "I'll bet a hundred dollars, if she's with us you will!" "Well, if you're going to be that way about it, but I'm serving her under protest," Joe said as he opened the beer cooler. Reaching instead for the .45 he kept cocked under the counter, he fired it slightly over his menacing customers' heads, shouting, "NOW, you sumbitches grab for 'em and we'll count heads when the smoke clears!" (Courtesy of Dan Sconsci.)

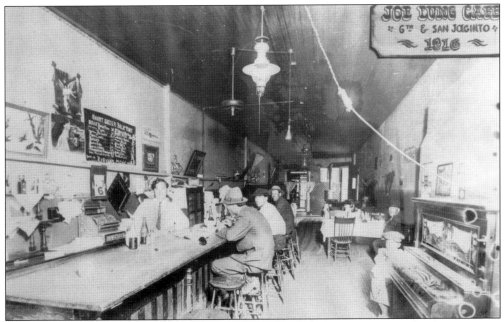

Men came to Joe Lung's village, Hoi Ping near Canton, recruiting laborers for the California railroads. In Texas, after the lines were completed, the other 299 workers returned to China or the West Coast. Joe immigrated to Sixth Street, where, since 1897, his restaurant began serving up more than food. Trust was so deeply a part of his business, this first Chinese restauranteur loaned money to his Mexican and black customers when banks would not, on nothing more than a handshake and, "you pay me when you can." Joe Lung understood that sharing builds trust, and he never lost a dime in his generosity. He founded the Lung's Chinese Kitchen dynasty, which, for 60 years, served five-star Lobster Cantonese—just what someone would expect from the people of Canton. (Courtesy of Austin History Center.)

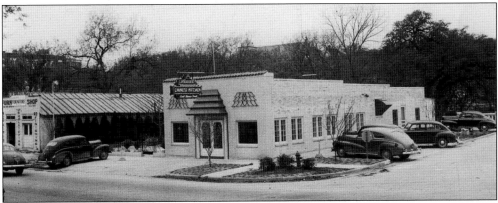

Lung's Chinese Kitchen on Red River delighted Austin for decades, but nobody around here had ever heard of Chinese food when founder Joe Lung opened at East Sixth and San Jacinto in 1897. People walking on Sixth during World War II may have seen a man come out of Lung's dressed in the uniform of Chiang Kai-shek's Chinese Airforce. Duke Tu was one of the Fab 100, Chinese military officers sent to America as interpreters for their pilots, who were then training for a secret mission in the Pacific Theater. Duke's son, Larry Tu, is vice president and general counsel for Dell Computers. Now Austin's Fab 10,000, these quality people are the backbone of our computer industry. (Courtesy of Joe Lung.)

Proud father Sam Lung holds the next generation, Joe, beside the family car. Note the running boards on this early postwar model. (Courtesy of Joe Lung.)

The child studying the airplane would go on to study medicine, becoming Austin ophthalmologist Mitchell Wong, M.D. The expansive one, charming the world with a smile that would be characteristic of him all his life, is the third generation of the Lung dynasty. Joe, also a restaurant owner, is named after his grandfather. (Courtesy of Joe Lung.)

Above, Sam Lung, who continued the half-century of Joe Lung's Restaurant on San Jacinto Street, is costumed as a dairyman for a 4H Club contest and displaying the family's prized steer. Joe and daughter Sandra raised this steer. Sandra Lung is remembered by her high school peers of the late 1950s as the stunning Eurasian beauty who was voted Most Beautiful in 1958. (Courtesy of Joe Lung.)

Joe Lung is seen here on the battleship *Texas*. When he was old enough to go to war, he was an interpreter for the National Security Agency. (Courtesy of Joe Lung.)

Young Joe and his mother, Lorene Lung, enjoy a moment in the family convertible. (Courtesy of Joe Lung.)

Joe Lung and his prized steer pose together. (Courtesy of Joe Lung.)

Pictured here are Sam Lung and son Joe looking like they know where they are going. The hats gentlemen wore then gave many, like Sam, an air of authority. (Courtesy of Joe Lung.)

Sam Lung, in his later years, with grandson Michael, stands beside the Lung's Chinese Kitchen delivery car. (Courtesy of Joe Lung.)

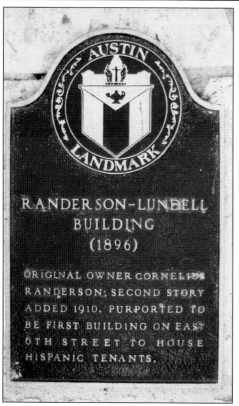

Waller Creek crosses under historic Sixth at Sabine Streets. Subject to periodic flooding, it was risky land for building. The 700 block was also the center of commercial and social life for Austin's Mexican community of the early to mid-1900s. In 1908, nineteen-year-old Ben Garza opened the first of his chain of meat markets at Sixth and Sabine Streets. El Original, Austin's first Tex-Mex restaurant, also started on the 700 block in 1923. El Matamoros and Monroe's Mexican Take Out were creations of Austin's first Mexican millionaire, Monroe Lopez. Old Austinites, or even newcomers, are known to say that Tex-Mex food is better in Austin than anywhere else in the United States. (Courtesy of Ozgur Cakar.)

Welcoming Hispanics as guests, this Runderson-Lundell building at 701 East Sixth served as an early gathering place for Mexican American Austinites and visitors. (Courtesy of Ozgur Cakar.)

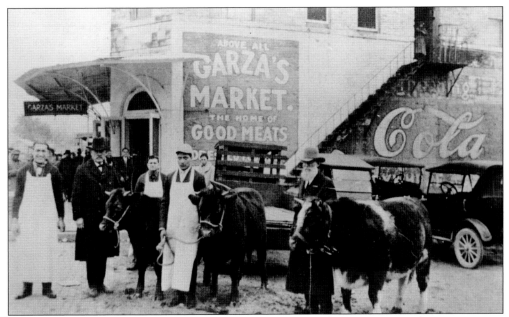

Owner Ben Garza, then only 19 years old, stands in his apron with a steer soon to become steaks and hamburgers for his 701 East Sixth meat market. This 1908 photograph shows the hotel upstairs, the first in the city to welcome Hispanics, and a model T delivery truck. Garza would become Austin's most successful Mexican market owner, with a chain of five stores and, later, a ranch and dairy in Oak Hill. (Courtesy of Austin History Center.)

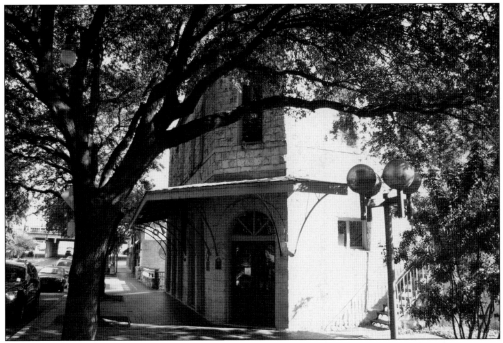

The early-20th-century heart of Sixth Street's Mexican-American enterprise was at 701. Lonnie Dillard lovingly restored this historic landmark for $200,000 and said, "You just walk by these old buildings on Sixth and they suck your money in." (Courtesy of Ozgur Cakar.)

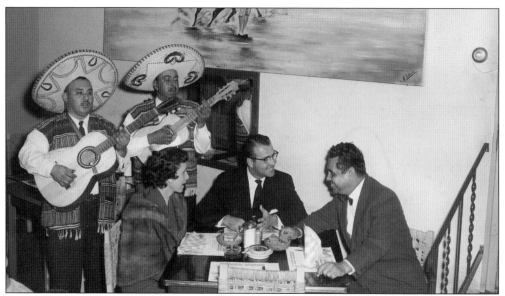

Monroe Lopez, Austin's first Mexican millionaire, is shown here chatting with customers at his El Matamoros Restaurant, half a block off Sixth facing East Avenue. Beginning in 1947, Lopez used his extraordinary culinary and marketing skills to bring the following firsts to Austin: takeout and delivery, an air-conditioned restaurant, tap beer in frosted mugs, and the irresistible crispy taco. But his most endearing creation, keeping countless University of Texas students from starvation, was the $1.25 all-you-can-eat Mexican dinner. He also owned Austin's KAZZ Radio Station, credited by *Billboard Magazine* as being the first FM station in America to regularly program rock and roll music when it was shunned by mainstream stations. So one might say that Monroe Lopez gave Austin the beat and all it could eat. (Courtesy of Austin History Center.)

At age five, this determined youngster peddled newspapers and shoe shines for a nickel on Sixth Street in the 1940s. Our future city councilman and mayor, John Trevino, is shown here in the overalls he wore picking cotton and to school. He remembers sitting on the steps of their home on East Sixth at age two and gazing in wonder at the neighborhood's artificial moonlight. Though born into impoverished circumstances, charitable impulses characterized his life. While working in the outreach program for St. Vincent De Paul, he entered the homes of the most needy Austinites and, in time, was invited to speak at a special conference at the University of Texas on the psychology of the poor. With no public speaking experience, his presentation so impressed the university that they nominated him to attend the 14th Annual International Conference on Social Welfare in Helsinki, Finland. (Courtesy of John Trevino.)

WESTERN UNION
TELEGRAM

The filing time shown in the date line on domestic telegrams is LOCAL TIME at point of origin. Time of receipt is LOCAL TIME at point of destination

404P CDT JUL 2 68 NS B284 KC484 BA514

SSJ492 B WAA173 WAZ1 WAZ1 DL PDB AR 2 EX WUX WALTHAM MASS PM 4 15

2 NFT

JOHN TREVINO

1619 EAST 1ST ST GR 6-0641 AUSTIN TX

THIS IS TO INFORM YOU THAT YOU HAVE BEEN SELECTED FROM AMONG
50 APPLICANTS FOR TOUR TO HELSINKI. PLEASE CONFIRM BY NIGHT
LETTER RESPONSE YOUR ABILITY TO PARTICIPATE INFORMATION ON
EXACT DATES FOR TOUR, CONFERENCE PROGRAM, AND OVERSEAS TRAVEL
PROCEDURS WILL FOLLOW
 SANFORD KRAVITZ BRANDEIS UNIVERSITY 894-6000 X619

SF1201(R2-65)

The sponsors of the
International Conference
on Social Welfare—the Ford
foundation, IBM, and Brandeis
University—sent John Trevino
this acceptance telegram.
He was the only participant
chosen from the Southwest.
The telegram is among his
most treasured possessions,
and it began his life as a public
figure. Right, Trevino begins
campaigning for public office.
(Both, courtesy of John Trevino.)

JOHN TREVINO . . . *Who he is . . , What he's done . . .*

* Volunteer with St. Vincent de Paul Society, Confraternity of Christian Doctrine and also Pan American Recreation Center

* Served on Travis County Grand Jury, April term, 1968

* Member of 14th International Welfare Conference in Helsinki, Finland

* Former member and past Secretary of League of United Latin American Citizens

* Director of Community Involvement Project, a program working with civic organizations to better utilize existing resources

* Urban Development Coordinator and Information and Referral Officer with local community action agency

* Former member and immediate past chairman of Austin Model Cities Commission

Austin History Center

TREVINO'S GOAL: A better Austin

* Be an **Active**, fulltime councilman in Place 4

* Reduce the polarization of our community

* Protect the consumer and the environment

* Preserve and restore Austin's historical sites

Just one promise

" to be HONEST and FAIR"

Trevino had become widely known in the community as a resourceful problem solver in his role as director of Austin's first neighborhood referral center, part of the federal government's War on Poverty initiative. In 1975, he was the first Hispanic elected to the city council, and he continued to serve his community as councilman, and then as mayor, for 13 years. (Courtesy of John Trevino.)

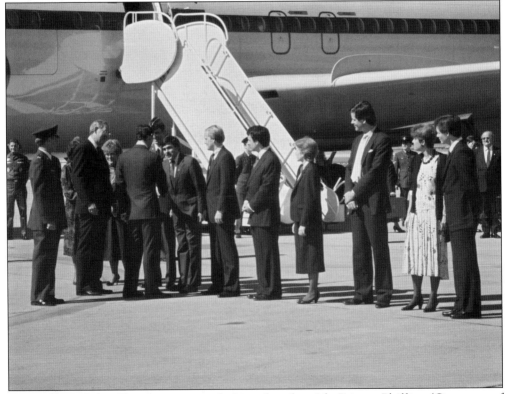

Councilman John Trevino is seen shaking hands with Prince Phillip. (Courtesy of John Trevino.)

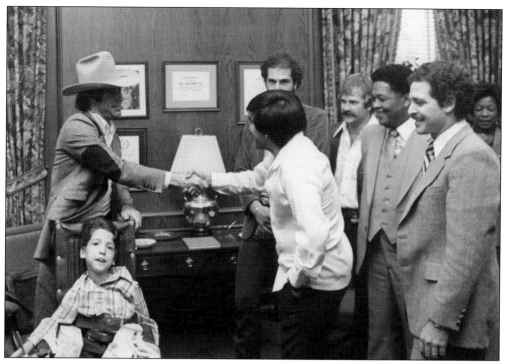

Here Mayor Trevino meets urban cowboy John Travolta. (Courtesy of John Trevino.)

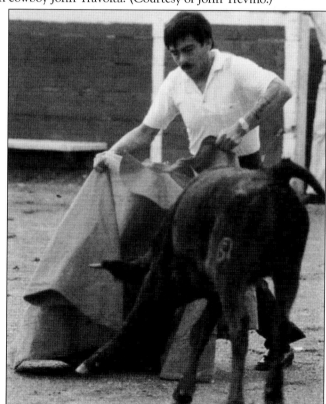

Never one to shy away from the challenges of life, John Trevino is shown here, having accepted an invitation from the mayor of Austin's sister city, Saltillo, Mexico, to fight a raging bull. (Courtesy of John Trevino.)

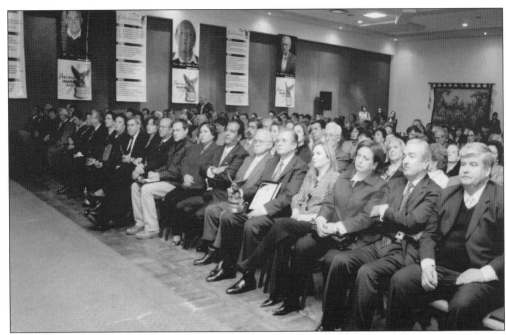

Even after leaving public life, John Trevino continued to find innovative ways to help the disadvantaged. The woman seated next to him in the photograph above is Maria Guadalupe, a social activist from Saltillo, Mexico. She told Trevino of Saltillo's transportation needs for senior and disabled citizens. Trevino induced Capital Metro to donate used equipment in an international act of brotherly love. In 2007, he was the first American to be honored by Presea IMARC, the Institute of Mexican North American Cultural Relations. (Both, courtesy of John Trevino.)

JOHN TREVINO, JR.

For the last 17 years, John Trevino has worked for the University of Texas, where his office teaches the system how to access minority businesses for the university's needs. The five-year-old paper peddler on the Sixth Street of 1943 had become our peddler prince. At 71, John Trevino is, as always, a river to his people. (Courtesy of John Trevino.)

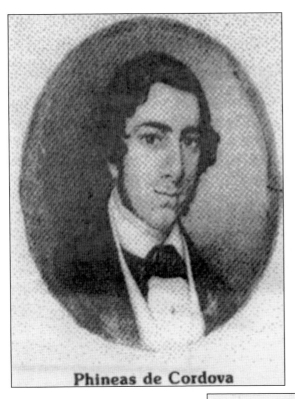

Phineas de Cordova

At the solicitation of 1849 governor Peter Bell, Phineas de Cordova relocated his printing office to the capital city. Austin's first Jew, de Cordova was descended from Spanish and Portuguese royalty who had become printers in Holland in the 1600s after being expelled from Spain by Queen Isabella's Decree of 1492. In 1850, he began publishing and editing Austin's first newspaper, the *Southwestern American*, a weekly publication. It carried ads, as seen below, for de Cordova's prospering land agency. At the time when he published the topographic map of downtown Austin (1872, page 71), he owned many parcels on Pecan Street, such as those adjacent to Carrington in the 500 block. Phineas de Cordova served as the first vice president, then president, of the newly formed Congregation Beth Israel in 1876. (Both, courtesy of Congregation Beth Israel.)

P. De CORDOVA. H. C. WITHERS.
 Late Corresponding Clerk Gen. Land Office

DE CORDOVA & WITHERS

TEXAS

LAND AGENCY,

(Established by P. De CORDOVA, in 1848.)

AUSTIN CITY.

DEALERS IN

LAND WARRANTS AND CERTIFICATES.

CERTIFICATES LOCATED AND PATENTED;
TAXES PAID ON LANDS IN ANY PORTION OF THE STATE;
TITLES EXAMINED, PERFECTED AND RECORDED IN THE PROPER
COUNTIES; LANDS EXAMINED, DIVIDED AND PREPARED
FOR SALE IN SMALL TRACTS TO SUIT THE TIMES.

CORRESPONDENCE DESIRED

WITH THOSE WISHING TO IMMIGRATE, AND ALL INQUIRIES
PROMPTLY ANSWERED.

Lands in Various Parts of the State For Sale.

SPECIAL ATTENTION PAID TO PERFECTING PRE-EMPTION
CLAIMS.

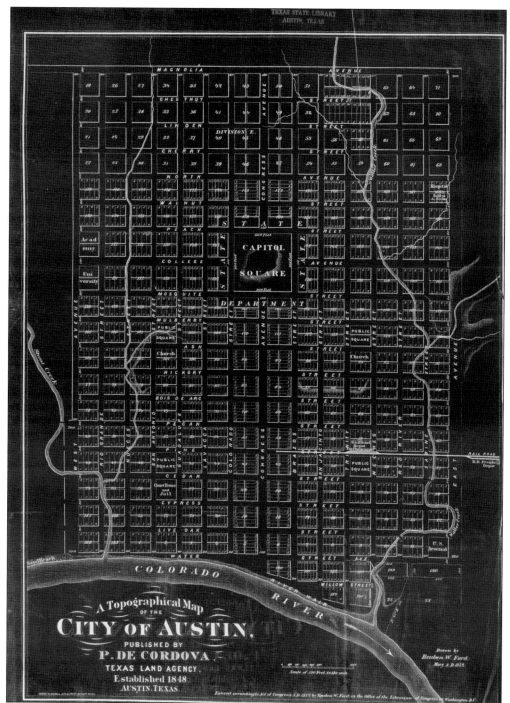

De Cordova was elected to the Texas Legislature for several terms, during which he served as its secretary and drafted the post–Civil War land laws. Appointed by the city, he used his skills as a surveyor to draw up this topographic map of 1872 Austin. Note that he still leaves space for a public marketplace at Trinity and Fifth Streets. Phineas de Cordova was a major property owner on Sixth. (Courtesy of Texas Public Land Office.)

Joe Koen was en route to a job in San Antonio, having been recruited from his native Vilna, Lithuania, in 1880. During a brief stop of the train, he walked from the Fourth Street terminal down toward the Colorado River and was so moved by what he saw, he said, "This is the most beautiful city in the world!" He never got back on the train. Watchmaking was a family business in Vilna, and Koen also brought from Vilna a 500-year tradition of welcoming Jews to the community, as the Grand Dutchy of Lithuania had done in 1325. Biographies of him say no Jew in need was ever turned away. He was a prime mover in Austin's first Jewish congregation, Beth Israel, of which he was president at the start of the 20th century until after World War II. He would begin annual election meetings with, "The meeting will come to order. We will now accept nominations for vice president." Though he dug into the fertile bedrock of East Sixth with the delicate tools of a watchmaker, he was willing to wield a pickax for his community, as he is shown here clearing land for Austin's first Jewish Temple. Now in their 130th year, Joe Koen and Sons Jewelry is the oldest family-run business in Austin. (Courtesy of Congregation Beth Israel.)

Hungarian-born Jacob Schmidt (left), 17, arrived at Ellis Island in 1908 and soon became a "merchant of the road." Also called a drummer, he carried his merchandise on his back, between farmhouses and into neighborhoods, until he could afford a mule. Prospering, he is shown here with his wagon and apparently a helper. Like the Lebanese Josephs and Daywoods, most of the earliest Sixth Street Jewish merchants arrived, as the old expression goes, "without a pot to pee in or a window to throw it out of." (Courtesy of James Kruger.)

In 2004, the City of Austin honored Jacob Schmidt by dedicating a fountain in his name at the skyline-piercing Frost Bank Tower. (Courtesy of James Kruger.)

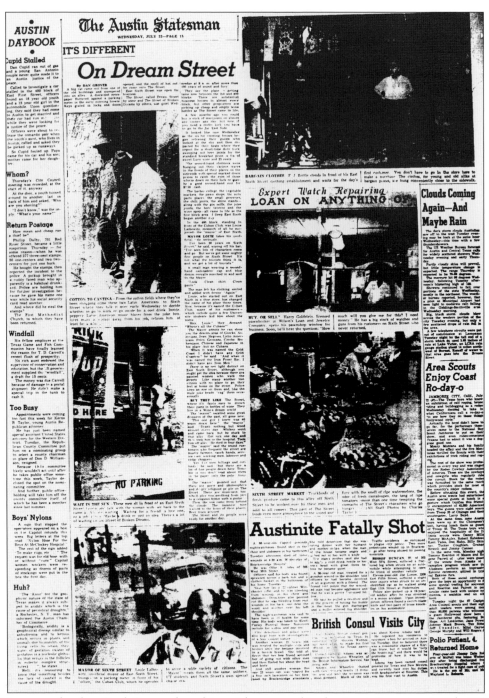

Times were hard on Sixth Street when this article appeared in the *Austin Statesman* in July 1953. In the third year of the worst drought in history, struggling merchants on Sixth Street were outraged by Grover's characterization of East Sixth: "the chili joints, along with the gin mills, the juke joints, the beer taverns and the wino spots—all come to life as the five block area of Deep East Sixth began another day." In spite of some factual inaccuracies, Grover's article had a ring of truth. (Courtesy of Austin History Center.)

74

And now for the reason for this book: In 1950, the author's family invested its life savings to open Kirby's Shoes at East Sixth and San Jacinto Streets. The family all worked in the store, which had no air-conditioning, only fans to blow the hot air around. The relentless Texas sun parched the state that year, beginning the worst drought in memory. There was no cotton to pick, so none of the legendary hoards of cotton pickers appeared on Sixth. Its first day in business, the store took in $8. But to quote the Southeast Asian proverb, "When the heat becomes unbearable, the gods send the rain," and by 1956–1957, Kirby's was an established success. (Courtesy of Austin History Center.)

The executive director of Sixth Street Austin, Josh Allen, calls this young man "the five-star chef of the historic district." Shown here at the same spot where, more than a century ago, Joe Lung served weary wagon drivers, Parkside's Shawn Cirkiel delights visitors and locals with such delectables as bone marrow salad—three baked bones with sea salt—or a dozen varieties of oysters flown in daily from eastern Canada. (Courtesy of Shawn Cirkiel.)

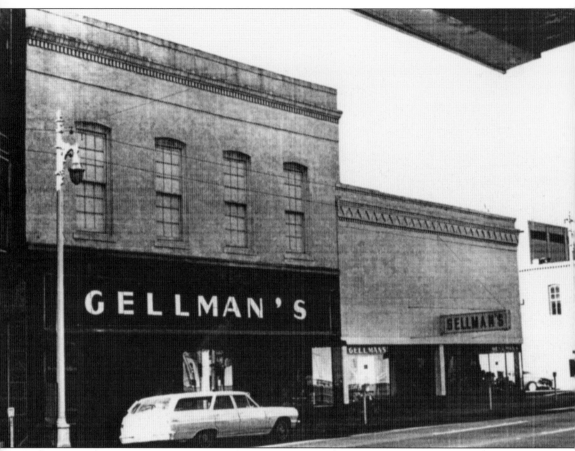

As a 20-year-old in czarist Russia, Dave Gellman faced involuntary military service but chose instead to scrape together passage to America, arriving without enough to buy a newspaper. He began by peddling simple wares in the south before moving into Texas. His first stores in Bremond and Marlin succeeded to such a degree that he was able to open The Leader at Brazos and Sixth Streets in 1922. Prohibition had emptied this corner where Lewis Loeb's Brunswick Bar had been at the start of the 20th century and Louis Weiss' Tavern had been until 1918. By 1929, he had accumulated the $42,000 he paid for 205–207 East Sixth, and Gellman's became the anchor clothing store on the street. For 60 years, Gellman's dressed men for work and kids for proms. Like other merchants on the street, Dave Gellman; his son, Sol; and his grandson Steven helped the new business arrivals, like the author's family in the early 1950s. "Run up to Gellman's and see if Sol has 'em" was often heard while the customer wanting the missing size 10EE work shoe waited, having been told, "The kid's got to go to the warehouse." (Courtesy of Austin History Center.)

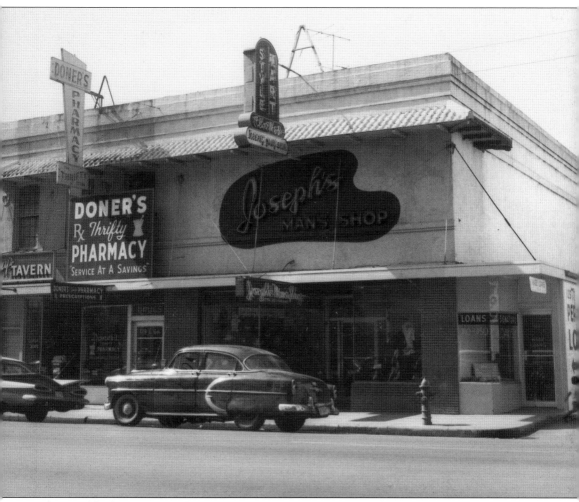

The 200 block of East Sixth in this 1959 photograph shows the former shoe repair shop at the alleyway, now an establishment for personal loans. When Walter Cronkite was a student broadcaster at KTBC radio, he would run across Sixth to the shop, knock at the door in back, and be given the latest scores on the big games. They knew these because it was a bookie joint with a teletype, in place there since 1900 when the building was an American Express telegraph office. In the early 1940s, Cronkite would hurry back to the KTBC studios in the Driskill and, before any other stations knew them, broadcast the scoop on the day's scores. Next door, one of Austin's three prominent Lebanese Joseph families had its upscale men's clothing store. To the left is Doner's Thrifty Pharmacy, from which the shrewd, high-energy pharmacist Abe Doner ran his 10 businesses. Among them was one of the first generic drug manufacturing firms, PharmaFac, which had many local physicians as shareholders. He sold PharmaFac for a small fortune. Then, at age 52, wearing his house slippers behind the counter as he always did, Abe Doner dropped dead. (Courtesy of Austin History Center.)

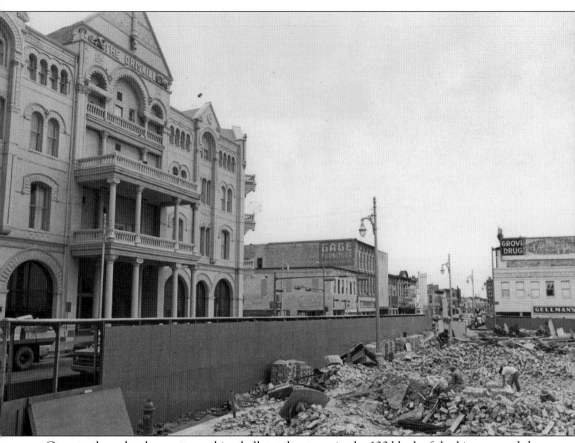

Gone to the redevelopment wrecking ball are the stores in the 100 block of the big guys and the little guys. Gone is the shine shop where the young Walter Cronkite got the scores from a bookie joint in back. Gone are the stores where future bankers John Bremond and Henry Hirshfeld made the beginnings of their fortunes. They may be gone, but they are not forgotten. (Courtesy of Austin History Center.)

Three

ICONS OF THE
STREET OF DREAMS

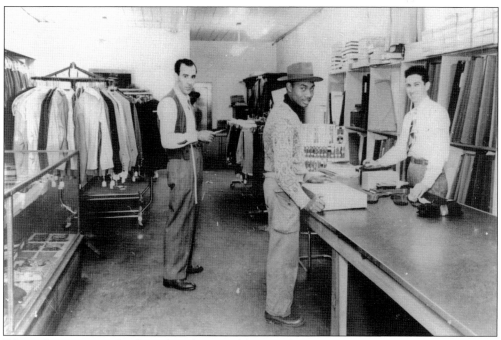

"Now, if you want to be draped in shape and hep on down, get your frantic fronts at Crown," crooned Dr. Hepcat, Leveda Durst, advertising Hyman Samuelson's shop at "408 East Sixth Street in beautiful downtown Austin." Pictured on the right, the honors graduate civil engineer has just returned from the war in the Pacific. On the left, the master tailor, Eli Gonzales, stands behind a smiling customer, who has been "draped in shape." Emblematic of mercantile East Sixth Street, this picture symbolizes its comfortable blend of many races. Crown Tailors was the fashion staple of the street, remaining "buttoned up" when all around was in disarray. (Courtesy of Austin History Center.)

This little shop (pictured above in 1959) prospered, and soon Congress Avenue was graced with SLAX, a high-fashion spot near the Paramount Theater. Hymie Samuelson (left) has been in movies, authored a still widely sold diary of his wartime experiences in New Guinea, and was a pivotal figure in raising the contributions for the building of the Dell Jewish Community Center. This elegant, generous man is the merchant prince of Sixth Street. Seen here at age 92 (April, 2010), he is a man still writing books, with a clear mind, steady hands, and a singing heart. (Above, courtesy of Austin History Center; left, courtesy of Hyman Samuelson.)

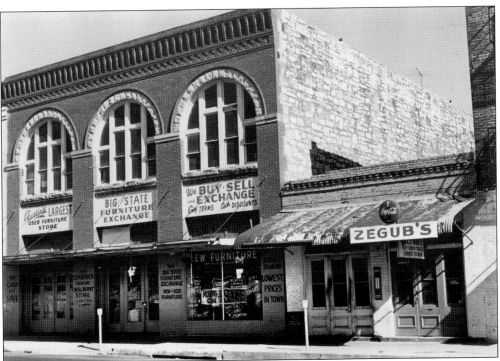

Ralph McElroy and Randy Baird dared to open the first continental cuisine restaurant on the rough-edged East Sixth of 1972. In this original carriage house of the St. Charles Hotel, Syrian immigrant George Zegub had repaired shoes for decades. Behind his shop, he had found an already old stand of mustang grapes growing up the outer wall of the St. Charles stable. Upon signing the lease with McElroy and Baird, he insisted it stipulate the grapes never be cut down. The two fashioned a grapevine covered arbor for their spectacularly successful Old Pecan Street Café. "Remove not the ancient landmark," Proverbs 22:28. (Above, courtesy of Austin History Center; right, courtesy of Dr. Emma Lou Linn.)

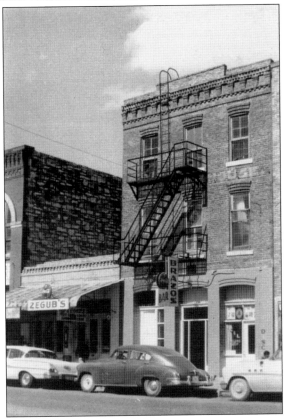

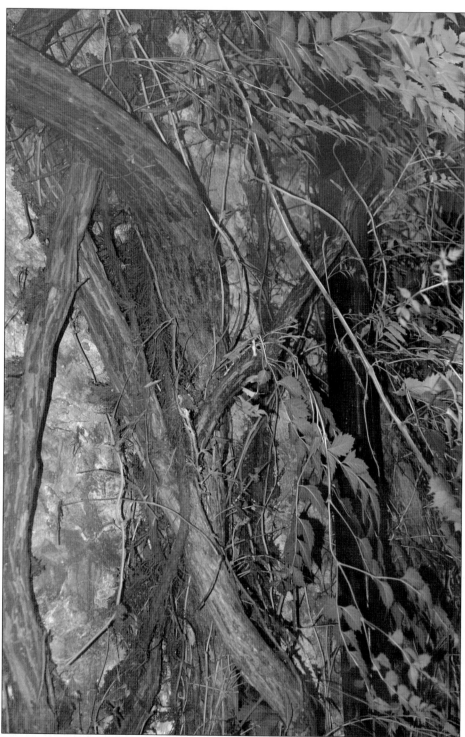

A fitting symbol of unlikely survivors in a surrounding world of shifting stone and concrete, George Zegub's grapes thrive today at Shakespeare's Pub. Rather than being supported by the 140-year-old wall, they seem to be holding it up. (Courtesy of James Kruger.)

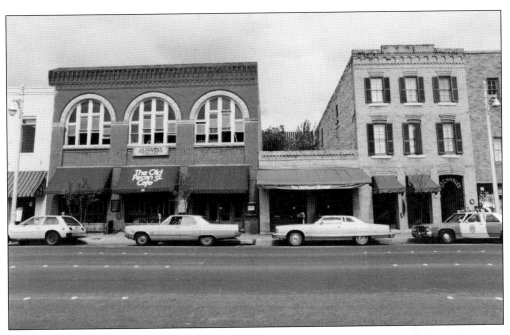

Twenty years ago, Bob Woody moved his Old Pecan Street Café around the corner from its original location to this charming spot on Trinity Street. A major player in the economic life of East Sixth, he owns 15 businesses in the historic district, generating revenues of more than $20 million a year. The food at the Old Pecan Street Café continues its trend-setting, four-decade tradition in a courtyard that feels like the New Orleans French Quarter. (Above, courtesy of Emma Lou Linn; below, courtesy of James Kruger.)

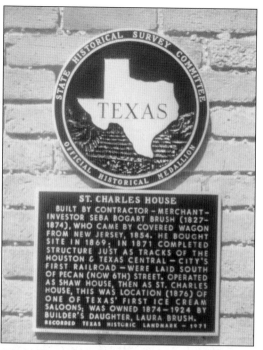

When St. Edward's University psychology professor Dr. Emma Lou Linn was a college student in 1960s Austin, she saw the unique potential of the old buildings on the street. The St. Charles House had seen better days as a once elegant hotel with a carriage house next door. It was once an indoor circus, into which customers were lured by a real baboon beating a drum out front. Austin's first ice cream parlor was run by Madame Saffroni, and later, the St. Charles was a brothel. This was run by Madame Frenchy. (Courtesy of Emma Lou Linn.)

Dr. Linn's restoration of 316 East Sixth was honored that year by the Heritage Society, and she was awarded the Citizenship Medal of Honor by the Austin Architects Society. Reflecting Dr. Linn's sense of humor, "froggy goin' courtin'" is seen here. (Courtesy of Emma Lou Linn.)

Dr. Linn began with the burned shell of what had most recently been the Brazos Bar. The courtyard of the new St. Charles House splashes to life beside a Victorian-era street lamp. (Courtesy of Emma Lou Linn.)

An open house featuring Dr. Linn's restoration at 316 East Sixth Street was attended by Travis County Historic Commission members, Heritage Society of Austin members, contractors, and many friends. Some of her former students are seen descending from the third to second story. (Courtesy of Emma Lou Linn.)

Decorative wrought iron gates accent the courtyard entrance, but the street was rough when Dr. Linn moved in on the third floor, so the gate was a necessity. (Courtesy of Emma Lou Linn.)

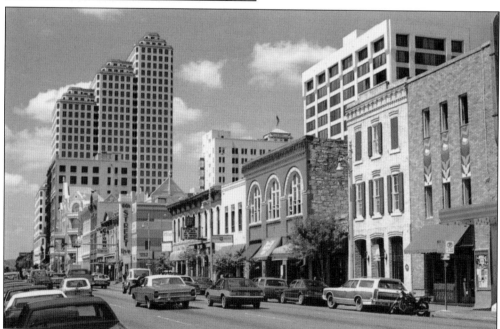

The pristine finished product of Professor Linn's rescue of 316 is seen with the decorative shutters in this photograph. Professor Emma Lou Linn, a tireless advocate for the preservation of Historic East Sixth, was elected to the Austin City Council and has left an indelible footprint on the Street of Dreams. (Courtesy of Emma Lou Linn.)

At Morley's Drug Store, O'Henry sold patent medicines like the ever popular Wonderful Eight, "good for whatever sort of pain afflicts you." A pharmacy for 100 years after the Civil War, it is now the Austin Visitor's Center, staffed by professional guides and historians. The old and the new find a place together here. The owl of the Frost Bank Tower gazes benignly upon a relic of another century. (Courtesy of Ozgur Cakar.)

Pick an outfit, with appropriate accessories of course. Leslie Cochran, Austin's most renowned transvestite, has appeared in them all and been bounced out of bars for rowdiness, but don't the boots with the orange and white seem just right? (Courtesy of James Haddox.)

Outside Brackenridge Hospital one night in 2009, a candlelight vigil was attended by many to offer spiritual support to Leslie Cochran. Something of a political activist, he once ran for mayor. A bikini with a beard—that was his trademark as he paraded about Sixth for more than a decade. Bar owners on the street, all 55 of them, have banned him for his exuberant behavior, and the cops have grown weary of handling him; yet sympathetic Austinites in the historic district launched a "Leave LESLIE Alone!" campaign. Unknown assailants beat him senseless, and the candlelight vigil outside Brackenridge was in prayerful hope that Austin would again see the self-described "Queen of Austin." And, as an enduring symbol of "Keep Austin Weird," Leslie lives! (Both, courtesy of James Haddox.)

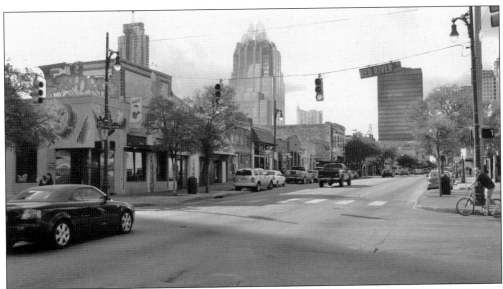

This corner of Sixth Street and Red River once housed the Cactus Theater, where television personality Cactus Pryor got his start in entertainment. Owned by his father, "Skinny" Pryor, it featured Spanish language movies. Cactus would sell patrons their tickets, pop the popcorn, and run the projector, all the while spouting stories and jokes, like those that so entertained the 1950s Austin television audience of *Cacti's Filltime*. This corner of Historic East Sixth continues to entertain the world with Esther's Follies, which has delighted Austin with their sparkling Vaudevillian comedy and song.

This delightful couple, Shannon Sedwick and Michael Shelton, are the owners of Esther's Follies, the rollicking vaudeville show at Red River and Sixth Streets (pictured above). Locals and visitors alike love their music and comedy, and shows are uniformly sold out Thursdays through Saturdays. Contributing to the community, as they did in their fund-raiser to save the Ritz, Sedwick and Shelton continue three decades of success, not folly, at Esther's Follies. (Courtesy of Shannon Sedwick.)

DRISKILL HOTEL
BUILT 1885-86 BY COL. JESSE L.
DRISKILL (1824-1890). CATTLE KING
WHO MOVED TO AUSTIN IN 1869.
BRICK DRESSED WITH LIMESTONE.
HAD THREE GRAND ENTRANCES--ONE
THE LARGEST ARCHED DOORWAY IN
TEXAS."LADIES' ENTRANCE" WAS ON
NORTHEAST. BUST OF COL. DRISKILL
IS OVER SOUTH ARCH. BUSTS OF HIS
RANCHER SONS ON EAST AND WEST.
RICH FURNISHINGS WERE SELECTED
BY COL. DRISKILL, WHO LEASED OUT
HIS HOTEL--SOUTHWEST'S FINEST
WHEN IT OPENED, CHRISTMAS 1886.
RECORDED TEXAS HISTORIC LANDMARK-1966

Listed in the National Register of Historic Places, the Driskill Hotel has been the cornerstone of the historic district for 125 years. Legend has it that cattle baron Col. Jessie Driskill lost the hotel in a card game, but it is more likely drought-driven family misfortune was why it changed hands. And change hands it did, 21 times since Driskill swung open its doors on Christmas Day 1885. (Courtesy of Ozgur Cakar.)

In 1908, the Driskill staged its first election watch party using a stereopticon to project national results against a large outdoor backdrop. Seen above is a 1964 election watch at the Driskill, and Lyndon Johnson was victorious. (Courtesy of Driskill Hotel.)

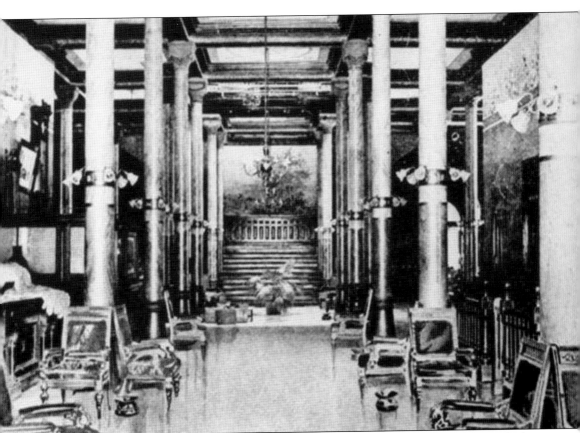

Littlefield's lights make reading in these hotel lobby chairs a pleasure. Restorations over the last 100 years have preserved the Driskill's 19th century elegance. (Courtesy of Driskill Hotel.)

This same view as the Driskill lobby on the preceding page shows how it has changed yet seems to stay the same. The Italian marble of the floor stirs the senses. (Courtesy of Ozgur Cakar.)

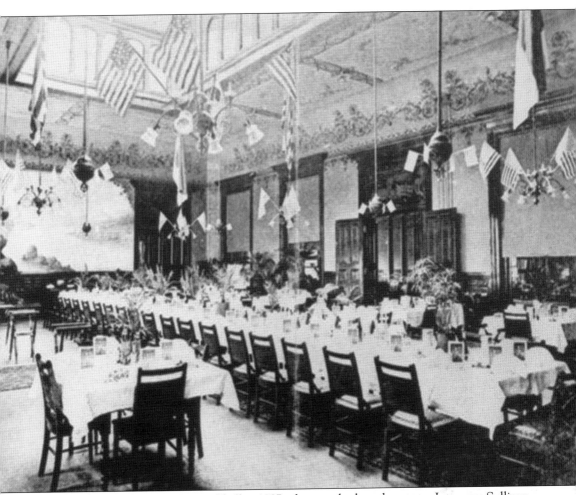

The Driskill hosted its first inaugural ball in 1887, when newly elected governor Lawrence Sullivan Ross began a tradition that has included Governors Hobby (1917), "Ma" Ferguson, Dan Moody, John Connally, and Ann Richards. Hobby's 1919 inaugural ball featured several orchestras playing in stereo behind forests of ferns, a setting reminiscent of a European court. (Courtesy of Driskill Hotel.)

Col. Jessie Driskill looks down on the staircase to the mezzanine (left). He does more than that for the Victorian-costumed Monica Ballard (below), owner of Austin Ghost Tours. Stories abound from the Driskill, where she sometimes smells the old colonel's cigar smoke. Many sightings of an old lady ghost have been reported from the mezzanine lady's room, one time by six young women simultaneously. (Both, courtesy of Ozgur Cakar.)

Entering from the Bois d'Arc Lane archway, one first passes the elegant formal dining room, then the piano bar, where the eyes fix upon this arresting sculpture. A man has fallen from his saddle, his boot is ensnared in the stirrup, and he is being dragged to death. The rider behind appears to be trying to shoot the horse to save his companion. If visitors can keep from jumping into the sculpture to help the battered cowboy, they will come to the mezzanine balcony, to this vision from another time and another world. (Both, courtesy of Ozgur Cakar.)

Descending the staircase to the artful Italian marble mosaic floor, one passes beneath this stained glass skylight toward the 1886 Bakery and Café. (Courtesy of Ozgur Cakar.)

The warm and inviting 1886 Bakery and Café serves, among other goodies, a cheese soup that still tastes as delectable as it did six decades ago. It is trademarked as Helen Corbet's Cheese Soup. (Both, courtesy of Ozgur Cakar.)

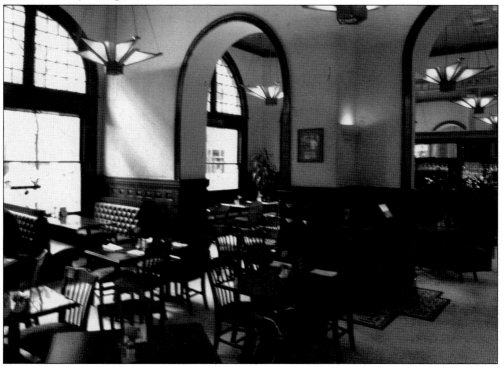

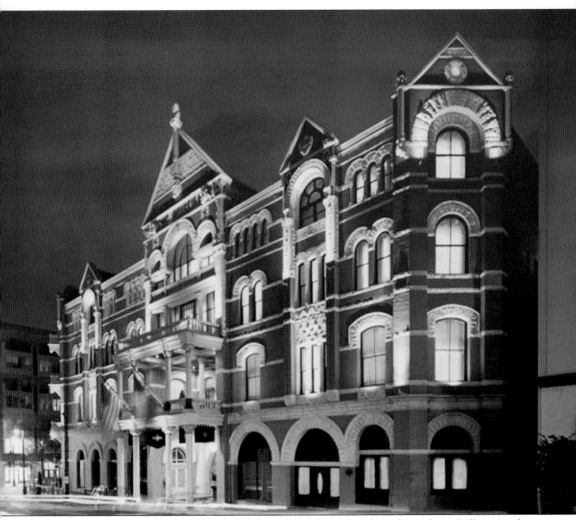

Hard as it is to imagine, in 1969 this Victorian treasure closed, and wrecking balls were about to replace inaugural balls. A new 19-story, modernistic tower was to rise from the rubble of the historic district's defining structure. But in 1970, a "Save the Driskill" community effort sold stock in the new Driskill Hotel Corporation, and soon corporate contributions had raised the rescue fund to $2 million. "The stone which the builders refused is the headstone of the corner," Psalm 117:22. (Courtesy of Driskill Hotel.)

During one of the multitude of reincarnations of this icon of Sixth, this 70-year history was published. Seemingly every old Austinite has a Ritz story. J. J. Hegeman, grandfather of present-day administrative law judge Larry Craddock, built and opened the Ritz in 1927. Sixth Street would not be the same without it. (Courtesy Tim League.)

One of the early licenses to operate a moving picture show is pictured here. (Courtesy of Tim League.)

The composite above includes some pictures from the Queen Theater at Seventh Street and Congress Avenue. J. J. Hegeman also built and owned the Queen before venturing onto Sixth. (Courtesy of Tim League.)

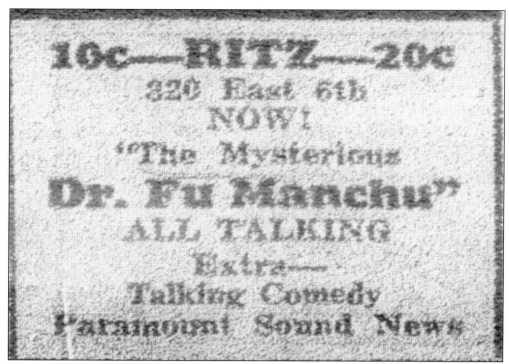

These images are from a time when a dime was really worth something. Old enough to comment that the Ritz had talking pictures, the above advertisement reminds those who see it of an ever-popular menace, Dr. Fu Manchu. (Courtesy of Tim League.)

This image will bring smiles to movie aficionados and a good many others as well. The classic *Cocoanuts*, the all-singing musical comedy, was shown at a popular price. (Courtesy of Tim League.)

Rugged star Jack Holt fights the enemy below in *Submarine* (left), and Abbot and Costello, along with the Andrew Sisters, are *Buck Privates*, which "starts today" at the Capitol. (Both, courtesy of Tim League.)

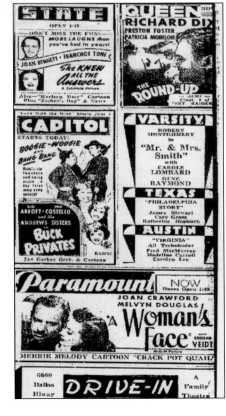

Though practically nobody could afford to see the authentic American hero Brown Bomber Joe Louis knock out King Levinsky in person, some people scraped together 15¢ for the thrill. (Courtesy of Tim League.)

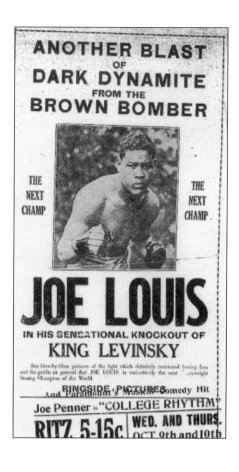

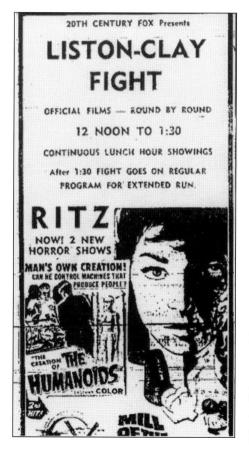

A mid-1960s Ritz invitation features a brawl between Sonny Liston and Cassius Clay. Soon the champion would change his name to one that would become known to more people than any other—Muhammad Ali. Two other features ask the age-old question, "Can we control machines that produce people?" (Courtesy of Tim League.)

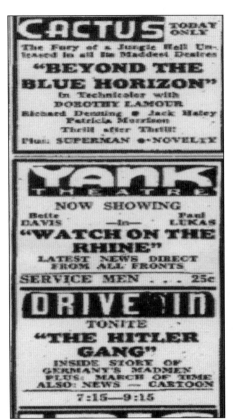

War was popular in these movie advertisements: *The Watch on the Rhine* at the Yank Theater on Sixth, *30 Seconds Over Tokyo* at the Paramount Theater, and *The Hitler Gang* at the drive-in. Abbot and Costello are *Lost in a Harem* at the State. (Courtesy of Tim League.)

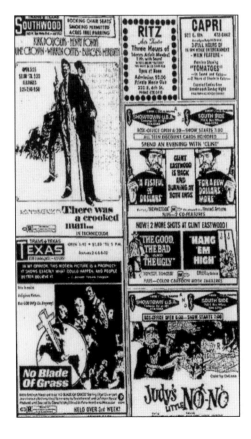

Spaghetti westerns dominate these advertisements, and the Ritz's has shrunk to a postage stamp-sized announcement: "Three hours of 16 mm adult entertainment." It closed as a movie house in the mid-1960s. (Courtesy of Tim League.)

After movies, the Ritz became a live entertainment venue, as this poster for punk rock groups Black Flag, Saccharine Trust, Dicks, and Big Boys promotes. (Courtesy of Tim League.)

Then the jarring Death Metal Attack 5 strikes the Ritz. But "Breakdown, Warning!" is included for the wary. (Courtesy of Tim League.)

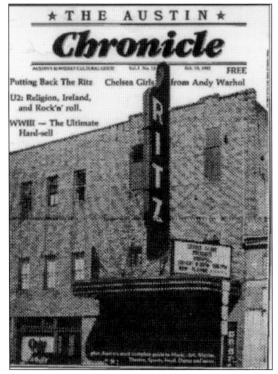

Heavy metal music pounded the structure of the Ritz as Gates of Steel proudly presented Slayer. (Courtesy of Tim League.)

Articles appeared, as far back as this one from a 1962 *Austin Chronicle*, speaking of putting back the Ritz. Something intrinsic to the history of Austin was slipping away. (Courtesy of Tim League.)

Benefits to save this icon of old Sixth were sponsored by Esther's Follies, who threw a Mardi Gras costume party featuring a group called The Uranium Savages. In this poster, the Ritz is likened to Botticelli's *Venus Rising*. (Courtesy of Tim League.)

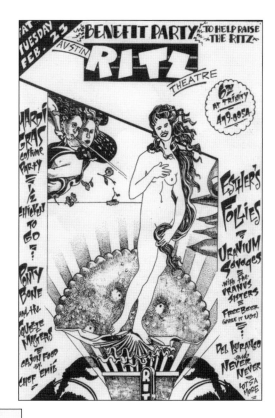

The University of Texas's *Daily Texan* in September 1974 begins with the following statement: "Like the legendary phoenix of myth, the Ritz Theater is rising anew from the dust of decay, and an unsavory reputation as a skin-flick palace." (Courtesy of Tim League.)

When Rice University mechanical engineering graduate Tim League beheld the Ritz in 2007, he said, "It needs more than just a new coat of paint." (Courtesy of Tim League.)

This sort of engineering would simply not do in Tim League's vision to rescue an 80-year-old treasure. He needed a central headquarters for his already highly successful Alamo Drafthouse, which he had started on Fourth Street. (Courtesy of Tim League.)

Tim League gutted it, down to the bare walls. Gone forever was the bat guano smell that so characterized the Ritz in its declining years. At one time, bats flew from this old relic at dusk, but now there was no place to roost. (Courtesy of Tim League.)

Beams of light in the shell of the old Ritz illuminate the steel beam that will hold up the second story of the Alamo Drafthouse. The beam is a symbol of Tim League's commitment to the permanent restoration of historic Sixth Street. (Courtesy of Tim League.)

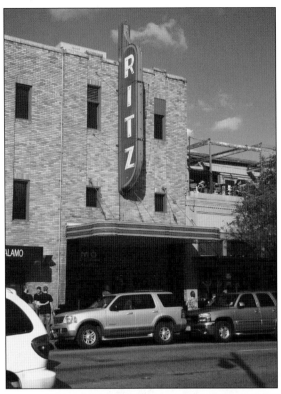

At the Alamo Drafthouse of today's Ritz, people enjoy having food brought by waiters and waitresses while they watch first-run movies. Without disturbing the facade of this ancient landmark, Tim League risked in the neighborhood of $1.7 million to re-create this magnetic entertainment venue. (Both, courtesy of Ozgur Cakar.)

Four

The Renaissance of East Sixth Street

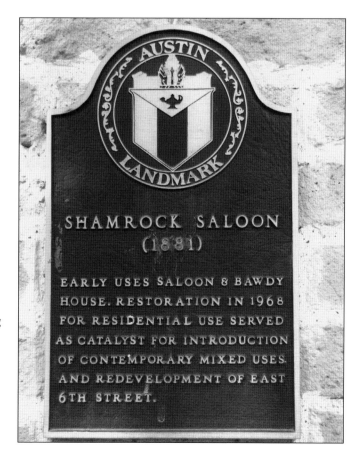

Every block of Sixth is a storybook and every building a page. This plaque at 410 East Sixth reminds people of a particularly colorful one. The Shamrock Saloon was the cornerstone for the rebirth of the most famous street in Texas. (Courtesy of Ozgur Cakar.)

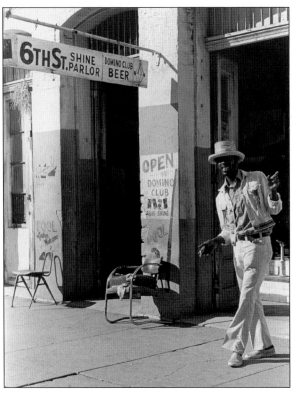

This 1974 photograph is from the rebirth period, when buildings were decaying. But, as always on Sixth, somebody's having fun. (Courtesy of Austin History Center.)

Into a cauldron of deterioration stepped noted architect and designer of NASA and MD Anderson Hospital David Graeber. He had a vision, which some thought a hallucination, of preserving the Dos Banderas ("Two Flags") building at 310 East Sixth Street. Condemned by the city for "nefarious activities within its portals," the former Shamrock Saloon was purchased by Graeber for $13,000. Preserving the soaring triple archways and bay windows, he gutted the remainder of the crumbling structure, replacing it with the Street's first modern living space—a townhouse with a glass-domed swimming pool. It would be Graeber's residence for the next four decades. The old Shamrock had gone from bawdy house to townhouse, beginning the rebirth of Sixth. (Courtesy of Austin History Center.)

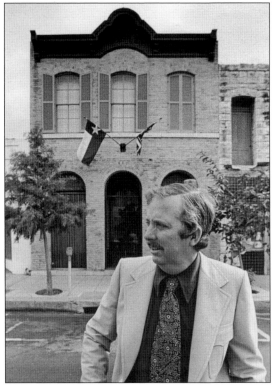

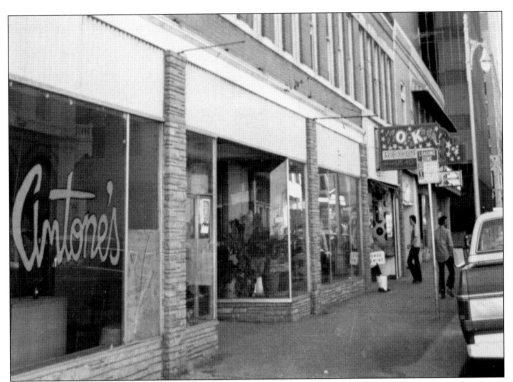

The heart of the Live Music Capital of the World began to beat anew in 1975 when daring promoter Clifford Antone opened the first rhythm and blues venue, reawakening Sixth. Seen above at Sixth and Brazos Streets, Antone's has been voted "Nightclub of the Year" by USA *Today* and fostered the career of Austin's pride and joy, Stevie Ray Vaughn. (Courtesy of Susan Antone.)

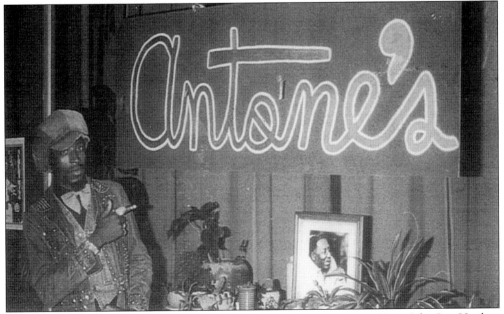

This customer points to the hot spot illuminated by such greats as B. B. King, John Lee Hooker, and Muddy Waters. (Courtesy of Susan Antone.)

This was the interior of Antone's shortly after opening in 1975. It is remembered by a generation as the liveliest spot on reborn Sixth. Antone's celebrates its 35th anniversary in the historic district at Lavaca and Fifth Streets under the able stewardship of Clifford's sister, Susan Antone. If Sixth Street is the heart of the Live Music Capital of the World, Antone's is its soul. (Courtesy of Susan Antone.)

Twenty-one-year-old Jerry Creagh restored the oldest existing building in the historic district, at 400 East Sixth, for his Wiley's Bar and Café, a nurturing spot for three decades. (Courtesy of Ozgur Cakar.)

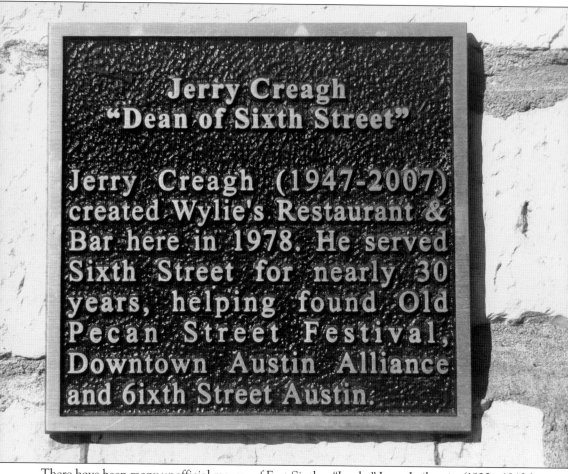

Jerry Creagh
"Dean of Sixth Street"

Jerry Creagh (1947-2007) created Wylie's Restaurant & Bar here in 1978. He served Sixth Street for nearly 30 years, helping found Old Pecan Street Festival, Downtown Austin Alliance and 6ixth Street Austin.

There have been many unofficial mayors of East Sixth—"Lanky" Leon Laibowitz (1930s–1940s) and Papa Joe Joseph (1950s–1980s) among them—but only one dean. A spirited advocate for preservation, Jerry Creagh is remembered as cofounder of the biannual Pecan Street Festival, when 300,000 visit historic Sixth. (Courtesy of Ozgur Cakar.)

Five

AN HOUR ON SIXTH STREET TODAY

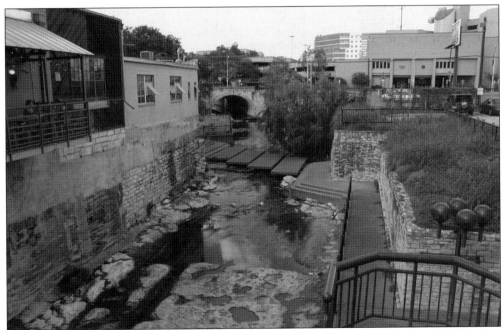

The $500 million plan to create another San Antonio River Walk on Waller Creek has been set in motion with the letting of the first $130 million of bond money. This year, a 5-foot-diameter shaft will be dug 60 feet below the surface, from Waterloo Park at East Twelfth all the way to the Colorado River. With periodic flooding finally contained, the constant flow of fresh water pumped from the river will invite adventurous kids and strolling lovers back to its banks. After all, "the abundant fresh water" of Waller Creek so impressed the 1838 Committee to Select the Capital, they favored this place above all others in the Republic of Texas. (Courtesy of Ozgur Cakar.)

A disabled man and his dog pause to watch a football game from the sidewalk of a Sixth Street pub. A patron talks to his dog, reminding all who witness that there is a place for everybody on the Street of Dreams. (Courtesy of Ozgur Cakar.)

This is a work without progress: 309 Sixth Street. Tax liens are said to keep this burned shell between two buildings from its next incarnation. How about public restrooms—the loo at 309? (Courtesy of Ozgur Cakar.)

The entire interior at B. D. Riley's pub was built in Ireland and reassembled to restore the historic Hannig building. The 19th-century cabinetmaker would beam with pride at the superb craftsmanship of the bar, snuggled into the place he built 140 years ago. (Courtesy of Ozgur Cakar.)

A popular activity all along Sixth Street today and in the past is clearly visible here: "moichendizing." (Courtesy of Ozgur Cakar.)

Suddenly, atop Maggie Mae's at Sixth and Trinity Streets, World Gone Mad offers a free serenade at a corner where music has been heard since 1872. (Courtesy of Ozgur Cakar.)

The Austin Rock & Roll Drum Corps showers the street below with music that had people stopping to dance on the sidewalk. Sometimes R&B and even a sprinkle of country music also enliven the district from Maggie Mae's. (Courtesy of Ozgur Cakar.)

The inspiration of Dean of Sixth Street Jerry Creagh has now blossomed into one of the nation's largest art and music festivals. With more than 250 jury-selected booths and dozens of music venues, the Pecan Street Festivals in spring and fall quicken the heartbeat of the Live Music Capital of the World. (Courtesy of Ozgur Cakar.)

Bats fly from the belfry of the Aces Club at San Jacinto. A regular stop on the haunted tours of Austin, it is known for the ragtime piano played late at night or early in the morning, yet nobody's there. (Courtesy of Ozgur Cakar.)

Bloody messes demonstrate for zombie rights all up and down Sixth, publicity for the premier of the movie *Zombies*. They menaced and bloodied passers-by, all the while pleading that they were people too. (Courtesy of Ozgur Cakar.)

Not far behind the demonstrators, a lone young woman walks. Too hot to wear her windbreaker, it is slung over her head, and her bedroll covers her torso. The demonstrators were feigning deterioration, but she is not. For some, Sixth is a street of broken dreams. (Courtesy of Ozgur Cakar.)

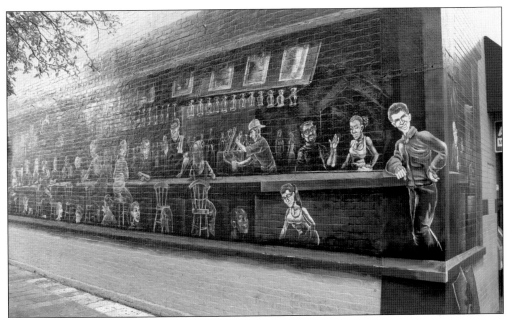

San Jacinto Boulevard at Sixth was once adorned by a cigar-smoking guy wearing sunglasses, but now it features the blessed relief of this clever perspective. There is no ledge on the wall, but onlookers would never know it by the shield leaning against it. (Courtesy of Ozgur Cakar.)

The dozen permanent music venues of Sixth require their own designated parking for the Live Music Capital of the World's over 8,000 musicians and bands, the largest number of any American city. The author (right) is appropriately labeled for his children and grandchildren: ATM. (Courtesy of Ozgur Cakar.)

Those who persevered and preserved this finest concentration of Victorian architecture in the Southwest have been rewarded with spectacular appreciation in the value of their properties. The average tax valuation of these treasures is $1.7 million. (Courtesy of Ozgur Cakar.)

The Grove Drug sign is ablaze on festival nights and weekends, when 20,000 or more party on Sixth Street after dark. Typically, the street is barricaded Thursday through Saturday nights, creating a quarter mile of traffic-free village in the historic district. But planners say it snarls downtown traffic, so solutions are being considered. (Courtesy of McCann-Adams Studio.)

Above is an architectural rendering of the elevation at street level, one of four proposals for the Sixth Street of the 21st century. (Courtesy of McCann-Adams Studio.)

This "Vision from Paradise" is how Sixth and Trinity Streets may soon appear. The McCann-Adams Studio's presentation to the 6ixth Street Austin Association shows 24-foot sidewalks with permanent café zones at curbside. Traffic will no longer have to be barricaded, since it will flow in three lanes, with mid-block valet parking. The softened edges of a tree-lined promenade look so like Pecan Street's Buaas Gardens of 1860. This corner, like the street itself, takes Austin through space, past time, and beyond imagination—back to where it all began. (Courtesy of Elizabeth Day.)